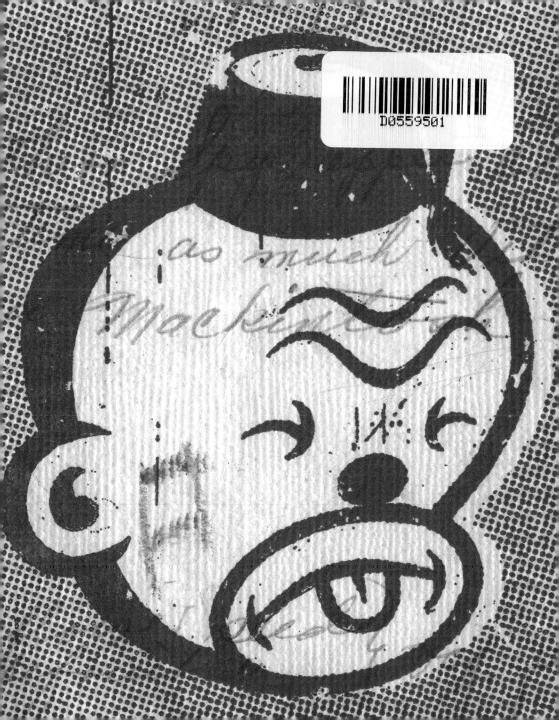

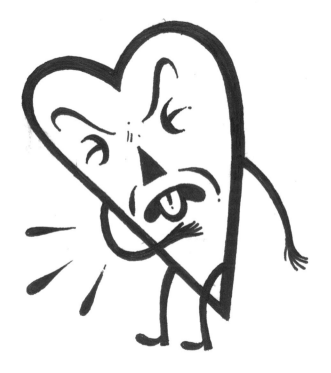

ne three little kittens

hey washed their mittens,

And hung them up to dry.

"Oh! mammy dear, look here, look

ur mittens we have washed."

"What! washed your mittens,

ou darling kittens!

But I smell a rat close by!

GARY TAXALI

I Love You, OK?

teNeues

FOREWORD

Shepard Fairey

Gary Taxali is one of those rare artists whose work is immediately inviting and familiar, yet idiosyncratic and unmistakable. Gary has created a universe of characters, slogans and motifs that is reminiscent of '50s advertising, comics and painted signs, but rendered in a minimal, sort of goofy, but very sophisticated style that could only be Gary Taxali. "Sort of goofy, but very sophisticated" you ask? What you call contradiction, I call duality. How would I explain duality? Hmmm...the band Love and Rockets put it pretty well: "Our little lives get complicated, it's a simple thing, simple as a flower, and that's a complicated thing." Gary's communications appear sweet and universal, but simplification is actually very complicated and often shrewdly manipulative. This duality is present everywhere in his art. Gary uses confident bold lines graphically and insecure fine lines metaphorically— fine lines between tragic and comic, between "in like" and "in love," between a character captioned "Good Husband" and the same character, now with added mustache, earning the caption, "Good Lover," and always the fine line between obvious and mysterious.

I think the way to get to know an artist is through his artwork. Artists often communicate their personalities and their concerns best through their art. I think Gary Taxali exemplifies this idea resoundingly. In all the interviews I've read with Gary, there is very little I could not have intuitively gleaned from looking at his artwork. He once said that an amusing memory from his childhood was, "watching a man's toupee fly off in the wind." Well, sometimes the wind needs a helper...and that's Gary Taxali, but in fairness, the guy losing the toupee is Gary Taxali too. Though I don't know Gary very well personally, I know his art work well enough to speculate that he struggled with the grade school conundrum of longing to be liked, and being too smart to waste time with the usual shallow pursuits required to be popular. I imagine that his combination of art and wit, and cuteness and darkness, may have been and continue to be, a form of inspired therapy.

One of the great things about Gary's art is that though it may function as therapy for him (as my art does for me) his characters and symbols are accessible and relatable enough for the average Joe or Jane to project their own problems and desires onto. Everyone has felt alienated at one time or another, and in that sense, the alienation in Gary's work is incredibly inclusive. Who can't relate to images of people slipping and falling, stump torsos with frowning faces on them seeming to say, *I feel like half a person,* or happy faces with red X's through them? Who hasn't wanted to burn a cop car, or felt empathy (wimpathy?) toward Popeye's lazy friend Wimpy? Who hasn't felt let down? Gary frequently illustrates the disconnect between how things are advertised and their honest reality. A faux advertisement of an old man holding a yo-yo with the word "Fun" as a descriptor below, looking like he either hasn't figured out how to use the yo-yo, or has become bored with its monotony. Either way he is clearly disappointed that the yo-yo, and maybe life in general, have not lived up to the sales pitch. In another image, a weed leaf is branded with "Funly," yet each leaf has a face with a wrinkled brow on it that looks anxious if not paranoid. Though much of Gary's work appears

to be about struggle and disappointment, there is gleeful mischief, beauty and poetic irony in the equation as well. One of my favorite of his images is of Chinese fingercuffs choking the victim's index fingers, but simultaneously yielding two big thumbs up in the process. Some of the warmth in Gary's work is more sublime like the nostalgia in his use of old book covers and ephemera. He clearly finds beauty in the things others might overlook or throw away. Then of course, there is the love in his craft. There is a delicate care and preciousness even in his intentionally distressed or deteriorated images. The illustrations are beautiful both as images and fluid, abstract mark making. Gary executes images and typography with the craft of an artisan sign-painter. Incidentally, he does not use the computer as a tool in his art process, which may explain the paradoxical character of perfect imperfection in his hand illustrated type. Gary is also a master of color theory. His palette, which marries carnival, advertising and comics is undeniably pleasing and provides the sugar to help the medicine go down.

Gary Taxali has been defined as illustrator, and even calls himself an illustrator, but intent, not style is what defines "fine art." An illustration sensibility is integral to Gary's art as it strives to both utilize and deconstruct the democratic aesthetics and conventions of illustration and advertising. Some of my favorite artists have not only been illustrators and "fine artists," but have combined illustration and fine art in a subliminally subversive way. For example, could anyone familiar with Warhol's art not analyze the battle of style over substance in his artsy glorification of mundane products? Warhol's Absolut ad served as an illustration, but also as an art piece with the potential to illuminate the superficial nature of product as hero. To be honest, I don't actually know which of Gary's pieces in this book are illustration assignments and which are personal art. His fluid integration of both illustration and art, or illustration as art, is a testament to the strength of his vision.

In closing, a lot of artists seem to find inspiration in angst, and Gary is likely no exception. His dissatisfaction may benefit the aesthetic satisfaction of this lonely world. So Gary, now that you have published a great book, don't feel too accomplished and lose your motivation. Just in case, I'll selfishly leave you with a few more of Love and Rocket's words of wisdom and inspiration.

> *When you're down*
> *It's a long way up*
> *When you're up*
> *It's a long way down*
> *It's all the same thing*
> *No new tale to tell*

Keep on truckin', Gary.

VORWORT

Shepard Fairey

Gary Taxali ist einer der wenigen Künstler, dessen Kunst sofort vertraut und einladend, aber dennoch eigenwillig und unverwechselbar ist. Er hat eine eigene Welt geschaffen, die aus Charakteren, Slogans und Motiven besteht, die an die Werbung, die Comics und die gemalten Schilder der 50er Jahre erinnert. Seine Kunst ist minimalistisch, ein bisschen albern, aber der Stil ist sehr anspruchsvoll und trägt die unverwechselbare Handschrift von Gary Taxali. „Ein bisschen albern, aber sehr anspruchsvoll?" fragen Sie. Sie nennen das Widerspruch – ich nenne es Dualität. Und wie würde ich Dualität erklären? Nun ... die Band Love And Rockets hat das recht gut zusammengefasst: „Our little lives get complicated, it's a simple thing, simple as a flower, and that's a complicated thing." [Unsere kleinen Leben können kompliziert sein. Es ist eine einfache Sache, einfach wie eine Blume, die kompliziert ist.] Die Botschaften von Garys Kunst scheinen lieblich und universal zu sein, aber Vereinfachung ist in Wirklichkeit sehr kompliziert und oftmals auf clevere Art manipulierend. Diese Dualität ist überall in seiner Kunst vorhanden. Grafisch verwendet er kühne Linien und metaphorisch unsichere, feine Linien – feine Linien zwischen Tragik und Komik, zwischen jemanden „mögen" und „in jemanden verliebt sein", zwischen einer Rolle, die als „guter Ehemann" betitelt ist und derselben Rolle, die jetzt einen Schnurrbart hat und als „guter Liebhaber" bezeichnet wird. Und es ist immer die feine Linie zwischen dem Offensichtlichen und dem Mysteriösen vorhanden.

Ich glaube, man lernt einen Künstler durch seine Kunst kennen, denn Künstler bringen ihre Persönlichkeiten und ihre Anliegen oftmals am besten durch Kunst zum Ausdruck. Hierfür ist Gary Taxali meiner Meinung nach das beste Beispiel. In all den Interviews mit ihm, die ich gelesen habe, ist kaum etwas enthalten, das ich nicht durch das Betrachten seiner Kunst intuitiv verstanden hätte. Einmal sprach er von einer amüsanten Kindheitserinnerung, als „er zuschaute, wie das Toupet eines Mannes im Wind davonflog". Nun, manchmal braucht der Wind einen Helfer – und das ist Gary Taxali. Fairerweise muss man jedoch sagen, dass Gary Taxali auch der Mann ist, der sein Toupet verliert. Obwohl ich Gary persönlich nicht sehr gut kenne, so kenne ich seine Kunst gut genug, um mir denken zu können, dass er sich in der Schule danach sehnte, gemocht zu werden und dass er zu smart war, um seine Zeit mit dem üblichen oberflächlichen Verhalten zu verbringen, das notwendig ist, um populär zu sein. Ich könnte mir vorstellen, dass seine Kombination aus Kunst und Geist, Charme und Dunkelheit eine Art Therapie gewesen sein könnte, die ihn inspiriert hat, und dies weiterhin tut.

Obwohl seine Kunst für ihn die Funktion einer Therapie erfüllt (wie das meine Kunst für mich tut), besteht eine Besonderheit von Garys Kunst darin, dass seine Charaktere und Symbole für jedermann zugänglich sind und jeder seine eigenen Probleme und Sehnsüchte hineinprojizieren kann. Hin und wieder fühlen wir uns alle entfremdet, und in diesem Sinne ist die Entfremdung in seiner Arbeit unglaublich präsent. Wer kann sich denn nicht mit Menschen identifizieren, die ausrutschen und hinfallen, Torsos mit Fratzen, die zu sagen scheinen, „Ich fühle mich wie ein halber Mensch". Oder fröhliche Gesichter mit einem roten X mittendurch. Wer hatte nicht schon mal den Wunsch, ein Polizeiauto anzuzünden oder hat mit Popeyes faulem Freund Wimpy Mitgefühl empfunden? Wer hat sich nicht schon mal im Stich gelassen gefühlt? Oft stellt Gary die Widersprüchlichkeit zwischen der Präsentation von Dingen in der Werbung und ihrer blanken Realität dar. Eine irreführende Werbung eines alten Mannes mit einem Jojo und der Bildunterschrift „Spaß", der so aussieht, als wüsste er nicht, was man mit einem Jojo macht oder den dessen Monotonie langweilt. Jedenfalls ist er ganz eindeutig enttäuscht, dass das Jojo oder vielleicht das

Leben insgesamt nicht hält, was der Werbeslogan verspricht. In einer anderen Darstellung wird ein Haschischblatt mit „spaßerzeugend" bezeichnet, aber auf jedem Blatt befindet sich ein Gesicht mit hochgezogenen Augenbrauen, das ängstlich, wenn nicht sogar paranoid aussieht.

Bei Garys Kunst scheint es oftmals um den Daseinskampf und um Enttäuschung zu gehen, aber in der Gleichung sind auch Verschmitztheit, Schönheit und poetische Ironie enthalten. Eine meiner Lieblingsdarstellungen ist die von chinesischen Fingerfallen, die die Zeigefinger des Opfers festhalten, die jedoch gleichzeitig durch „Daumen hoch" Zustimmung signalisiert. Teilweise ist die Wärme in seinen Arbeiten sublimer, wie die Nostalgie, wenn er alte Bucheinbände und Gelegenheitsgrafiken verwendet. Gary sieht Schönheit in Dingen, die andere vielleicht nicht beachten oder wegwerfen würden. Und dann ist natürlich sein Handwerk mit Liebe verbunden. Sogar in seinen absichtlich abgenutzt aussehenden Darstellungen sind eine filigrane Sorgfalt und Kostbarkeit vorhanden. Seine Illustrationen sind als Darstellungen und als fließende, abstrakte Zeichnungen schön. Er führt Darstellungen und Typographie mit der Kunstfertigkeit eines künstlerischen Schildermalers aus. Ebenso setzt er den Computer nicht für seine Kunst ein, was den paradoxen Charakter der perfekten Unvollkommenheit in seinen per Hand illustrierten Schriften erklären könnte. Außerdem ist Gary ein Meister der Farbentheorie. Seine Palette, die Karneval, Werbung und Comics vereint, ist zweifellos angenehm und ist der Zucker, der einem hilft, die bittere Medizin zu schlucken.

Gary wurde als Illustrator bezeichnet, und er selbst bezeichnet sich auch so. Was zu den „bildenden Künsten" gehört, wird jedoch durch die Absicht, nicht den Stil definiert. Die Sensibilität seiner Illustrationen ist Bestandteil seiner Kunst, da sie bemüht ist, die demokratischen Ästhetiken und Konventionen von Illustration und Werbung zu nutzen und gleichzeitig zu dekonstruieren. Einige meiner Lieblingskünstler waren nicht nur Illustratoren und „bildende Künstler", sondern sie haben es verstanden, Illustrationen und bildende Kunst auf subtilste und subversivste Weise miteinander zu vereinen. Könnte man, wenn man die Kunst Andy Warhols kennt, in seiner künstlerischen Glorifikation alltäglicher Produkte nicht den Kampf zwischen Stil und Substanz erkennen? Die Absolut-Werbung von Warhol diente als Illustration, jedoch auch als Kunstwerk mit dem Potenzial, das oberflächliche Wesen des Produkts als Held zu beleuchten. Ehrlich gesagt weiß ich eigentlich nicht, welche von Garys Werken in diesem Buch Auftragsarbeiten und welche seine persönliche Kunst sind. Seine Verschmelzung von Illustration und Kunst oder vielmehr seine Illustrationen als Kunst bezeugen die Intensität seiner Vision.

Nicht unerwähnt bleiben darf die Tatsache, dass für viele Künstler Angst inspirierend ist, und Gary dürfte wohl keine Ausnahme sein. Seine Unzufriedenheit könnte seiner ästhetischen Zufriedenheit in dieser einsamen Welt zugutekommen. Gary, nachdem Du jetzt ein hervorragendes Buch veröffentlicht hast, fühlst Du Dich hoffentlich nicht zu vollendet und verlierst Deine Motivation. Selbstsüchtig möchte ich Dir noch einige Worte der Weisheit und Inspiration von Love And Rocket mitgeben:

> *Wenn man am Boden ist,*
> *ist der Weg nach oben lang,*
> *wenn man oben ist,*
> *ist der Weg nach unten lang.*
> *Es ist alles gleich,*
> *Es ist nichts Neues zu berichten.*

Mach so weiter, Gary.

PRELUDE

Shepard Fairey

Gary Taxali est un de ces artistes rares dont l'œuvre semble immédiatement accueillante et familière tout en étant particulière et unique. Il a créé un univers de personnages, slogans et motifs qui rappellent les pubs, les illustrés et les panneaux peints des années 50, le tout présenté dans un style minimaliste, un peu barjot mais très sophistiqué qui ne peut être que Gary Taxali. « Un peu barjot mais très sophistiqué » vous allez me demander ? Ce que vous appelez une contradiction, je l'appelle dualité. Comment vais-je expliquer la dualité ? Humm... le groupe Love and Rockets l'a bien exprimé : « nos petites vies deviennent compliquées, c'est une chose simple, simple comme une fleur et c'est quelque chose de compliqué.» Les communications de Gary semblent gentilles et universelles mais la simplification est en fait très compliquée et souvent habilement manipulatrice. Cette dualité est présente partout dans son art. Il fait appel à des lignes audacieuses et sûres d'elles-mêmes graphiquement et des lignes fines manquant d'assurance métaphoriquement, un fil ténu entre le tragique et le comique, entre « bien aimer » et « être amoureux », entre un personnage intitulé « bon mari » et le même personnage maintenant avec en plus une moustache ce qui lui vaut le titre de « bon amant » et toujours ce fil ténu entre le manifeste et le mystérieux.

Je pense que la meilleure façon de connaitre un artiste c'est à travers son art. Les artistes communiquent souvent leurs personnalités et leurs interrogations à travers leur art. Je pense que Gary Taxali personnifie cette idée d'une façon éclatante. De tous les entretiens de lui que j'ai lus, il y a bien peu de choses que je n'aurais pas pu glaner avec intuition en regardant ses œuvres. Il a dit une fois qu'un souvenir amusant de son enfance était de « voir le pastiche d'un home s'envoler avec le vent ». Bon parfois le vent a besoin d'aide ... et vient Gary Taxali, mais pour être juste, le gars qui perd son postiche c'est aussi Gary Taxali. Bien que je ne connaisse pas très bien Gary personnellement, je connais son art suffisamment bien pour spéculer qu'il a lutté avec la tâche ardue de l'école primaire d'aspirer à être aimé tout en étant trop intelligent pour perdre son temps avec les comportements superficiels indispensables pour être populaire. J'imagine que ce mélange d'art et d'humour, de séduction et de noirceur ait pu être et continue d'être une forme de thérapie inspirée.

Une des grandes choses de l'art de Gary est qu'il peut lui servir de cure (comme mon art le fait pour moi) ses personnages et ses symboles sont suffisamment accessibles et identifiables pour que le commun des mortels puissent y projeter ses propres problèmes et désirs. Tout le monde s'est senti aliéné à un moment ou à un autre et dans ce sens là, l'aliénation dans son œuvre est incroyablement exhaustive. Comment peut-on ne pas s'identifier aux images de gens qui glissent et tombent, des bustes courtauds affublés de visages grimaçants qui semblent dire, « j'ai l'impression d'être une demi-personne » ou des visages heureux avec des X rouges qui les traversent ? Qui n'a pas éprouvé le désir d'incendier une voiture de police ou ressenti de l'empathie (wimpathie ?) envers l'ami paresseux de Popeye, Wimpy ? Qui ne s'est pas senti abandonné ? Gary illustre souvent le décalage entre la façon dont les choses sont présentées et la réalité honnête. Une fausse publicité avec un vieil homme tenant un yoyo avec le mot « s'amuser » qui semble être une description et on a l'impression qu'il n'a pas su trouver comment jouer au yoyo ou qu'il s'ennuie en raison de la monotonie. D'une façon ou d'une autre, il est manifestement déçu que le yoyo et peut-être la vie en général n'ont pas été à la hauteur de l'argument de vente. Sur une autre image une feuille d'une plante sauvage a droit au titre de « drôle » et pourtant chaque feuille a un visage avec un sourcil renfrogné qui semble anxieux pour ne pas dire parano.

Bien que la majeure partie de l'œuvre de Gary semble consacrée à la lutte et la déception, on trouve aussi dans l'équation de l'espièglerie joyeuse, de la beauté et de l'ironie poétique.

Une de mes préférées parmi ses images est celle de menottes chinoises qui serrent les index de la victime mais en même temps on voit deux pouces qui se lèvent en signe de victoire. Une autre part de chaleur dans son œuvre est plus sublime, comme la nostalgie au moment de faire appel à des couvertures de vieux livres et des papiers à usage éphémère. Il est clair que Gary trouve une beauté dans les choses que d'autres vont laisser passer ou jeter. Et puis bien sur, il y a l'amour de son art. On trouve un soin délicat et de la séduction même dans ses images intentionnellement abimées ou détériorées. Les illustrations sont belles et fluides en tant qu'images et jouent dans l'abstrait. Il exécute des images et des typographies avec l'habileté d'un artisan qui peint des panneaux. Il convient de noter qu'il n'utilise pas d'ordinateur comme outil de procédure artistique ce qui pourrait expliquer le caractère paradoxal de l'imperfection parfaite de ses illustrations à la main. Gary est aussi le maitre de la théorie de la couleur. Sa palette, qui marrie le carnaval, la pub et les illustrés comiques est sans l'ombre d'un doute agréable à regarder et fournit le sucre qui aide à faire passer le médicament.

Gary a été défini comme un illustrateur et il se désigne lui-même comme un illustrateur mais l'intention et non pas le style c'est ce qui définit l' « art ». La sensibilité d'une illustration fait partie intégrante de son art du fait qu'elle s'efforce d'utiliser et de déconstruire les esthétiques et les conventions démocratiques de l'illustration et de la pub. Certains parmi mes artistes préférés ont été non seulement des illustrateurs et des « artistes des beaux-arts » mais ils ont su aussi allier les illustrations et les beaux-arts d'une manière sublimement subversive. Par exemple, quelqu'un qui connait bien l'art de Warhol pourrait-il ne pas analyser la bataille de style contre la substance dans sa glorification artistique de produits quotidiens ? La pub Absolut de Warhol a servi d'illustration mais aussi d'œuvre d'art avec le potentiel d'illuminer la nature superficielle du produit en tant qu'héro. Pour être honnête, je ne sais pas à ce point quelles sont les œuvres de Gary dans ce livre qui sont des missions d'illustration et quelles sont celles qui sont de l'art personnel. Son intégration fluide de l'illustration et de l'art ou de l'illustration en tant qu'art est un témoignage de la force de sa vision.

En conclusion, de nombreux artistes semblent trouver de l'inspiration dans l'angoisse et Gary n'est probablement pas une exception. Son insatisfaction peut favoriser une satisfaction esthétique dans ce monde de solitude. Donc Gary, maintenant que tu as publié un superbe livre, ne te sens pas trop accompli sinon tu vas perdre ta motivation. Au cas où, je te quitte égoïstement avec quelques autres paroles de sagesse et d'inspiration de Love and Rockets :

> *Quant tu es déprimé*
> *C'est long pour se relever*
> *Quand tu es debout*
> *C'est long pour se recoucher*
> *Tout est pareil*
> *Pas de nouvelle histoire à raconter*

Continue ta route Gary.

PREFAZIONE

Shepard Fairey

Gary Taxali è uno di quei rari artisti la cui opera appare immediatamente invitante e familiare, e tuttavia al tempo stesso idiosincratica e inconfondibile. Il suo è un universo di personaggi, slogan e motivi che evocano le pubblicità, i fumetti e i manifesti degli anni Cinquanta, ma interpretati in uno stile minimale, un po' buffonesco, e al tempo stesso molto sofisticato che può solo essere identificato con Gary Taxali. Mi chiederete: "Un po' buffonesco e sofisticato"? Quella che sembra una contraddizione, in realtà per me è una dualità. Come spiegarla? Per dirla con la band Love and Rockets: "Le nostre piccole vite si complicano, è semplice, semplice come un fiore, e questa è una cosa complicata." Il linguaggio di Gary è dolce e universale, ma la semplificazione è un processo complicato e spesso astutamente manipolatorio. Questa dualità è onnipresente nella sua arte. Traccia delle linee che sono graficamente forti e decise e metaforicamente sottili e insicure – linee sottili fra il tragico e il comico, fra il "mi piaci" e il "sono innamorato", tra un personaggio con la didascalia "Buon Marito" e lo stesso personaggio, ma con i baffi, che si merita quella di "Buon Amante"; e c'è sempre la linea sottile tra l'ovvio e il misterioso.

Penso che il miglior modo di conoscere un artista sia attraverso la sua opera. Spesso gli artisti comunicano al meglio la propria personalità e le proprie preoccupazioni attraverso l'arte. E Gary Taxali esemplifica questa idea clamorosamente. Da tutte le interviste di Gary che ho letto emerge molto poco che non avrei altrimenti potuto intuire semplicemente osservando il suo lavoro. Una volta ha detto che un ricordo divertente della sua infanzia era "guardare il parrucchino di un uomo che volava portato via dal vento". Beh, qualche volta il vento ha bisogno di un aiutante... come Gary Taxali, ma a dire il vero, Gary è anche il tipo che perde il parrucchino. Non conosco Gary molto bene personalmente, ma conosco il suo lavoro abbastanza per immaginare che a scuola abbia voluto essere popolare tra i suoi coetanei ma che allo stesso tempo, data la sua intelligenza, abbia evitato di perdere tempo con le cose superficiali che si devono fare per diventarlo. Immagino che la combinazione che c'è in lui di arte e umorismo, carineria e cattiveria, possa essere stata, e continui a essere, una forma ispirata di psicoterapia.

Una delle cose speciali dell'arte di Gary è che, sebbene probabilmente funzioni da terapia per lui (allo stesso modo in cui succede per me con il mio lavoro artistico), i suoi personaggi e simboli sono accessibili per il fruitore medio e disponibili per introiettarvi i propri problemi e desideri. Ognuno di noi si sente alienato prima o poi, e l'alienazione nella sua opera è incredibilmente inclusiva. Per esempio, chi non s'identifica con immagini di gente che scivola e cade, torsi mozzati con facce dalle espressioni accigliate che sembrano dire: "Mi sento a metà", o facce felici passate ai raggi X? Chi non ha voluto almeno una volta dare fuoco all'auto di un poliziotto o non ha provato empatia nei confronti di Poldo, l'amico pigro di Braccio di Ferro? Chi non si è mai sentito deluso? Gary spesso illustra la sconnessione tra il modo in cui le cose vengono pubblicizzate e come sono in realtà. Penso, ad esempio, alla finta pubblicità del vecchio con in mano lo yo-yo: la sua espressione ti dice che quest'uomo o non ha la più pallida idea di come usarlo o che si è annoiato a morte facendolo andare su e giù, e la parola "Divertimento" gli fa da didascalia. In un caso o nell'altro è chiaramente deluso che lo yo-yo, e forse la vita in generale, non siano stati al massimo delle sue aspettative. In un'altra immagine un cespuglio di erbacce è titolato "Da ridere", e tuttavia ogni foglia ha una faccia accigliata che la fa sembrare ansiosa o addirittura paranoide.

Sebbene le tematiche di buona parte del lavoro di Gary sembrino essere scontro e delusione, anche una malizia allegra, bellezza e ironia poetica fanno parte dell'equazione.

Una delle mie immagini preferite è quella di una trappola per dita cinese che blocca gli indici della vittima, ma che allo stesso tempo lascia liberi due grossi pollici girati in su. In altri casi il suo spirito affettuoso emerge in un modo più sublime, come con la nostalgia nell'uso di copertine di vecchi libri e oggetti desueti. Gary chiaramente trova del fascino in cose che altri potrebbero ignorare o buttare. Poi, naturalmente, c'è l'amore che mette nel proprio mestiere. Ci sono attenzione delicata e ricercatezza anche nelle sue immagini intenzionalmente più angosciate o deteriorate. Sono illustrazioni belle sia come immagini sia come segni fluidi e astratti. Gary esegue immagini e stampa con la maestria di un cartellonista pubblicitario. Tra l'altro non usa il computer nel processo artistico, il che forse spiega la caratteristica paradossale di perfetta imperfezione nei suoi grafemi disegnati a mano. Gary è anche un maestro nella teoria del colore. La sua tavolozza, che sposa i colori del carnevale, della pubblicità e dei fumetti, è innegabilmente piacevole, come lo zucchero che ti aiuta a far ingoiare una medicina amara.

Gary è stato definito un illustratore, e lui stesso si definisce così, ma è l'intenzione, non la tecnica, che definisce le "belle arti". La sensibilità dell'illustratore è parte integrante della sua opera che si sforza di utilizzare e decostruire al tempo stesso l'estetica democratica e le convenzioni di illustrazione e pubblicità. Alcuni dei miei pittori preferiti sono al tempo stesso illustratori e artisti, e la loro genialità si concretizza nel combinare illustrazione e arte in modi subliminalmente sovversivi. Per esempio, chiunque abbia un minimo di familiarità con l'opera di Warhol come potrebbe non notare la battaglia tra stile e sostanza nella sua glorificazione artistica del banale quotidiano? Tipica in questo senso è l'icona che ha creato per la pubblicità della Vodka Absolut che serve sia come illustrazione, sia come oggetto d'arte con il potenziale di illuminare la natura superficiale del prodotto come immagine di prodotto. A dire la verità, non so quali dei pezzi di Gary che sono in questo libro siano illustrazioni commissionate e quali siano il frutto della sua ispirazione personale. La sua fluida integrazione di illustrazione e arte, o di illustrazione come arte, è la prova della forza della sua visione.

Per concludere, molti artisti trovano ispirazione nell'angoscia, e Gary non sembra fare eccezione. La sua insoddisfazione è in grado di procurare soddisfazione estetica in questo mondo solitario. Quindi, Gary, adesso che hai pubblicato questo bel libro, non sentirti tanto appagato da perdere la motivazione! Per sicurezza, egoisticamente ti lascio citando ancora frasi di saggezza e ispirazione dei Love and Rockets:

> *Quando sei giù*
> *il cammino per tornare su è lungo,*
> *quando sei su*
> *il cammino per tornare giù è lungo,*
> *è sempre la stessa cosa,*
> *niente di nuovo sotto il sole*

Continua così, Gary.

PRÓLOGO

Shepard Fairey

Gary Taxali es uno de esos raros artistas cuyo trabajo se torna inmediatamente atractivo y familiar, y a la vez peculiar e inconfundible. Ha creado una gran cantidad de personajes, eslóganes y motivos que tienen reminiscencias de la publicidad, historietas y letreros pintados de los años 50, pero realizados en un estilo minimalista, disparatado, pero muy sofisticado, que sólo podría pertenecerle a él. Se preguntarán, "¿Disparatado, pero muy sofisticado"? Lo que para algunos es una contradicción, para mí es una dualidad. ¿Cómo explicar la dualidad? Mmm... el conjunto "Love and Rockets" lo expresó muy bien: "Nuestras pequeñas vidas se complican; es algo tan simple como una flor, y eso es complicado." Las comunicaciones de Gary parecen dulces y universales, pero la simplificación es, en realidad, muy complicada y, a menudo, astutamente manipuladora. Esta dualidad está presente en todo su arte. Gary utiliza en sentido gráfico líneas seguras y atrevidas, y en sentido metafórico, líneas delgadas e inseguras; líneas delgadas entre trágicas y cómicas, entre "me gusta" y "me encanta", entre un personaje denominado "Buen marido" y el mismo personaje, ahora con bigote, catalogado con el nombre de "Buen amante", y siempre la delgada línea entre lo obvio y lo misterioso.

Creo que la forma de llegar a conocer a un artista es a través de su arte. A menudo, los artistas comunican mejor sus personalidades y sus problemáticas a través de su arte. Considero que Gary Taxali es un ejemplo evidente de esta idea. En todas las entrevistas que leí de él, hay muy poco que no habría podido descubrir en forma intuitiva contemplando su obra. Una vez dijo que un recuerdo gracioso de su infancia era "ver volar con el viento el peluquín de un calvo". Bien, a veces el viento necesita ayuda... y ese es Gary Taxali; pero a decir verdad, el hombre al que se le vuela el peluquín también es Gary Taxali. Aunque no lo conozco mucho personalmente, conozco su obra lo suficiente como para especular que luchó con el dilema escolar de ser aceptado y el ser demasiado inteligente para perder tiempo con las pequeñeces que generalmente hacen falta para ser popular. Me imagino que su combinación de arte e inteligencia, y belleza y oscuridad, pueden haber sido —y continuar siéndolo— una forma de terapia inspiradora.

Una de las grandes características de la obra de Gary es que, si bien puede funcionar como terapia para él (al igual que mi arte lo es para mí), sus personajes y símbolos son lo suficientemente accesibles e identificables como para que la gente común pueda proyectar en ellos sus propios problemas y deseos. Todos nos hemos sentido alienados en algún momento dado, y, en ese sentido, la alienación de su obra resulta increíblemente inclusiva. ¿Quién no puede identificarse acaso con imágenes de gente resbalando y cayendo, con pequeños torsos con caras que parecieran decir, "Me siento sólo la mitad de una persona", o caritas felices cruzadas por X rojas? ¿Quién no ha deseado incendiar un coche patrulla, o no ha sentido empatía con Wimpy, el amigo holgazán de Popeye? ¿Quién no se ha sentido desilusionado? Gary a menudo ilustra la desconexión entre la forma en que las cosas se publicitan y su honesta realidad. Una publicidad artificial de un hombre mayor sosteniendo un yo-yo con la palabra "Diversión" por debajo, que pareciera que o nunca logró comprender cómo usarlo o se aburrió de su monotonía. De cualquier modo, está claramente desilusionado de que el yo-yo, y tal vez la vida en general, no hayan estado a la altura del argumento de venta. En otra imagen, una hoja tiene un cartel de "divertido", pero cada hoja tiene una cara con el ceño fruncido que parece ansiosa, si no paranoica.

Si bien gran parte del trabajo de Gary parece versar sobre la lucha y la desilusión, hay también una picardía jubilosa, una belleza irónica y poética en la ecuación. Una de mis imágenes favoritas es la de un trabadedos chino que ahorca a los índices de su víctima

y, a la vez, levanta dos grandes pulgares. Algo de la calidez de su trabajo es más sublime, como la nostalgia que denota el uso de tapas de libros viejos e impresiones efímeras. Gary claramente encuentra belleza en las cosas que otros soslayan o desechan. Además, desde luego, está el amor en su arte. Hay un cuidado delicado y valioso, incluso en sus imágenes intencionalmente afligidas o deterioradas. Las ilustraciones son hermosas, tanto en su carácter de imágenes como en su creación de marcas fluidas y abstractas. Gary ejecuta imágenes y tipografías con el arte de un pintor de carteles. Por cierto, no usa la computadora como herramienta en el proceso artístico, lo cual podría explicar el carácter paradójico de la perfecta imperfección de la tipografía dibujada a mano. Gary es también un maestro de la teoría del color. Su paleta, que se conecta con el carnaval, la publicidad y las historietas, es indiscutiblemente agradable y suministra el azúcar para ayudarnos a tomar la medicina.

Gary ha sido definido como un ilustrador, y él mismo se autodenomina así, pero es la intención, y no el estilo, lo que define al "arte". La sensibilidad para la ilustración es parte integral de su arte, al intentar tanto usar como deconstruir la estética y convenciones democráticas de la ilustración y la publicidad. Algunos de mis artistas favoritos no sólo han sido ilustradores y "artistas", sino que también han combinado la ilustración y el arte de un modo subliminalmente subversivo. Por ejemplo, ¿podría cualquiera familiarizado con el arte de Warhol, dejar de analizar la batalla del estilo en oposición a la sustancia en su glorificación artística de productos mundanos? La publicidad "Absolut" de Warhol sirvió como ilustración, pero también como obra de arte con el potencial de iluminar la naturaleza superficial del producto como héroe. Honestamente, no sé realmente cuáles de las obras de Gary en este libro son trabajos de ilustración y cuáles, parte de su arte personal. Su fluida integración de la ilustración y el arte —o de la ilustración como arte—, es el testimonio de la fuerza de su visión.

Como cierre, muchos artistas parecen encontrar inspiración en la angustia, y Gary, probablemente, no sea una excepción. Su insatisfacción puede ser beneficiosa para la satisfacción estética de este mundo solitario. Por eso, Gary, ahora que has publicado un excelente libro, no te sientas demasiado realizado al punto de perder la motivación. Por las dudas, y respondiendo a un acto de egoísmo, te dejaré con otras palabras sabias e inspiradoras de "Love and Rockets":

> *Cuando estás deprimido*
> *Cuesta mucho levantarse*
> *Cuando estás eufórico*
> *La caída es dolorosa*
> *Es todo lo mismo*
> *Nada nuevo bajo el sol*

Sigue adelante, Gary.

FOREWORD

Aimee Mann

I remember when I was first thinking about playing music. I wasn't even really a musician yet, just a kid who was trying to learn other people's songs on a guitar. I would think about the idea of trying to write songs, and how surely every possible combination of chord progression and melody had already been written, and on top of that, there are no new ideas in the world, so really, how is it even possible to create something new and interesting and different?

I still sometimes have this attitude about fine art. Not being someone who paints and draws, or rather, being someone who paints and draws only in the most passing and amateur sense, I have never reached that point where you take the form and absorb it and it becomes a way to translate stuff that is in your head. So I am always kind of shocked when I come across something that makes me totally rethink that position.

I first saw Gary's stuff in 2007, at a little gallery near where I live called La Luz de Jesus. It's not really a gallery-gallery, but part of a bookstore/tchotchke store, the kind of place that has books about tattoos and cars and murders and Ouija boards and weird toys and dolls. In the back is a gallery. I was thinking vaguely about what I wanted for the artwork for my next record. I knew I wanted something really graphic, because I loved graphic art and poster art and print ads and things like that. (I have a treasured collection of old *Graphis Annuals* that I got from my father, who used to be in advertising.) There were a few things at this gallery I liked, one or two who were doing a sort of cartoony kind of thing, and one in particular I was sort of considering, and then I turned a corner and saw Gary's stuff and I was just like, BOOM. There it is.

His stuff has everything I like. It's original, it's graphic, it has color and humor, it's personally symbolic in a way that is oddly relatable, and it's very reflective of Gary himself. Gary is this fascinating combination of deeply sardonic and completely open and encouraging. He stays with me sometimes when he visits Los Angeles and he's always 100% enthusiastic and excited about the two of us (and whoever else might be around) getting out the Gocco printing press and Goccoing together. All are welcome. Art is not precious to him, but it is sacred, which is not the same thing. His willingness to share his excitement about art is touching. It's lovely to see how constant his attention to art is. The sardonic side comes out with people who take art for granted. Ask him to do something for free and tell him he should do it "for the exposure" and see what happens. And yet he has worked tirelessly and devotedly for me on my album package for *Smilers* for what I can tell you is a fraction of what he is worth. He will sacrifice for art, he will suit up and show up with enthusiasm for it, but if you treat it with disrespect, he will fuck you up.

There are a handful of people in my life who remind me of what art is really all about. You forget it sometimes. And sometimes it takes a watchdog at the gate to make sure it doesn't get trifled with. And then you go through that gate, and remember that life has meaning, and that we are all connected, and this is the way we protect that connection. You protect it by doing it constantly, by sharing it, by teaching, by fighting off those who would give it away and devalue it and cheapen it and strip it of its magic. Gary is the watchdog. He loves you, ok? He really does. Just take a look. You can tell.

VORWORT

Aimee Mann

Ich kann mich gut daran erinnern, als ich das erste Mal darüber nachdachte, Musik zu machen. Ich war noch nicht mal eine richtige Musikerin, nur eine Jugendliche, die versuchte, Lieder anderer Leute auf der Gitarre zu spielen. Ich dachte darüber nach, Lieder zu schreiben und auch darüber, dass sicherlich jede mögliche Kombination von Akkordfolgen und Melodien bereits komponiert worden war. Darüber hinaus gibt es einfach keine neuen Ideen. Wie sollte es also möglich sein, etwas Neues, Interessantes und Anderes zu schaffen?

Diese Einstellung habe ich manchmal noch zu den bildenden Künsten. Ich bin nicht jemand, der malt und zeichnet, oder vielmehr, ich male und zeichne auf sehr amateurhafte Weise und nur gelegentlich. Ich habe nie diesen Punkt erreicht, wo man eine Form nimmt, sie verinnerlicht und damit die Dinge, die man in seinem Kopf hat, umsetzt. So bin ich also immer leicht schockiert, wenn ich auf etwas stoße, das mich veranlasst, meine Einstellung völlig zu überdenken.

Garys Arbeiten habe ich zum ersten Mal 2007 in einer kleinen Galerie in der Nähe meiner Wohnung gesehen, die La Luz de Jesus heißt. Es ist keine Galerie im eigentlichen Sinne, sondern Teil eines Buch- und Schnick-Schnack-Ladens. Es ist die Art von Geschäft, die Bücher über Tattoos, Autos, Morde und Ouija-Bretter sowie verrückte Spielzeuge und Puppen verkauft. Im hinteren Teil des Ladens ist eine Galerie. Ich dachte ein bisschen darüber nach, wie meine nächste CD aussehen sollte. Ich wusste, dass ich etwas sehr Grafisches wollte, da ich grafische Kunst und Poster sowie Printwerbung und solche Dinge liebe. (Ich habe eine Sammlung alter Graphis Annuals, die mir viel bedeutet. Ich bekam sie von meinem Vater, der in der Werbung tätig war.) In dieser Galerie waren ein paar Dinge, die mir gefielen. Ein oder zwei waren ein bisschen wie Cartoons, und insbesondere ein Stück hatte ich in die engere Wahl gezogen. Dann aber sah ich Garys Arbeiten, was wie eine Offenbarung war. Genau das war es, was ich suchte.

Seine Arbeit vereint alles, was ich mag. Sie ist originell, grafisch, farbenfroh und humorvoll, sie ist auf persönlicher Ebene symbolisch, und zwar so, dass man sich auf merkwürdige Weise angesprochen fühlt, und Garys Arbeiten sind ein Spiegel seiner selbst. Gary ist gleichzeitig zutiefst sarkastisch und vollständig offen und ermutigend. Manchmal wohnt er bei mir, wenn er in Los Angeles ist. Er ist immer absolut begeistert und voller Enthusiasmus, wenn wir beide (und wer sonst gerade noch anwesend ist) die Gocco-Druckpresse herausholen und zusammen Drucke anfertigen. Alle sind willkommen. Für ihn ist Kunst nichts Kostbares, aber sie ist heilig, was nicht dasselbe ist. Seine Bereitschaft, andere an seiner Begeisterung über Kunst teilhaben zu lassen, ist bewegend. Es ist schön zu sehen, mit welcher Beständigkeit er der Kunst seine Aufmerksamkeit widmet. Seine sarkastische Seite tritt bei Leuten zutage, die Kunst als selbstverständlich hinnehmen. Fragen Sie ihn mal, ob er etwas umsonst machen würde, oder sagen Sie ihm, dass er etwas machen sollte, „um seinen Namen bekanntzumachen", und Sie werden sehen, was passiert. Dennoch hat er unermüdlich und hingebungsvoll an dem Artwork für mein Album *Smilers* gearbeitet, und zwar für einen Bruchteil dessen, was er verlangen könnte. Er bringt Opfer für die Kunst, er putzt sich heraus und ist mit Begeisterung dabei, aber wenn Sie Kunst respektlos behandeln, wird er Sie fertigmachen.

In meinem Leben gibt es einige wenige Menschen, die mich daran erinnern, worum es bei Kunst wirklich geht. Manchmal vergisst man das. Und manchmal braucht man einen Wachhund am Tor, um darauf zu achten, dass man sie nicht zu leicht nimmt. Dann passiert man dieses Tor und denkt daran, dass das Leben bedeutungsvoll ist, dass wir alle miteinander verbunden sind und dass wir diese Verbindung auf diese Weise schützen. Man schützt Kunst, indem man ständig Kunst macht, sie weitergibt, lehrt, indem man die bekämpft, die sie einfach weggeben, entwerten und herabsetzen und sie ihres Zaubers berauben. Gary ist dieser Wachhund. Er liebt Sie, OK? Wirklich! Schauen Sie doch mal. Man sieht es.

PRELUDE

Aimee Mann

Je me souviens lorsque j'ai pensé faire de la musique pour la première fois. Je n'étais pas encore vraiment un musicien, juste un gamin qui essayait d'apprendre les chansons des autres sur sa guitare. J'avais l'idée d'essayer d'écrire des chansons et je pensais que très certainement toutes les combinaisons possibles de progression des accords et des mélodies avaient déjà été écrites et en plus il n'y avait pas d'idées nouvelles dans ce monde et donc comment pouvait-on même créer quelque chose de nouveau, d'intéressant et de différent ?

Il m'arrive parfois d'encore avoir ce genre d'attitude pour les beaux-arts. N'étant pas quelqu'un qui peint et qui dessine ou plutôt étant quelqu'un qui peint et dessine uniquement à temps perdu et comme un total amateur, je n'ai jamais atteint ce stade où vous prenez une forme pour la pénétrer et elle devient un moyen de transmettre ce que vous avez dans la tête. Et donc c'est toujours pour moi un choc lorsque je suis confronté à quelque chose qui va m'obliger à revoir complètement ce point de vue.

J'ai vu pour la première fois les œuvres de Gary en 2007, dans une petite galerie près de là où j'habitais et qui s'appelait La Luz de Jesus. Ce n'était pas vraiment une galerie-galerie, mais une partie d'une librairie/magasin de bibelots, le genre d'endroit où on trouve des livres sur les tatouages, les voitures, les crimes, les jeux d'ouija, les jouets et les poupées bizarres. Au fond il y avait une galerie. Je pensais vaguement à ce que je souhaitais pour la pochette de mon prochain disque. Je savais que je voulais quelque chose de vraiment graphique, parce que j'aime l'art graphique, les posters artistiques, les pubs et des choses du même genre. (J'ai une collection de vieux *Graphis Annuals* que j'adore et qui me vient de mon père qui était dans la publicité.) Il y avait certaines choses dans cette galerie qui me plaisait, une ou deux qui évoquaient une sorte d'illustrés et une en particulier qui me faisait réfléchir et puis j'ai pris un angle et j'ai vu les œuvres de Gary et ce fut comme un BOUM. Voilà c'est là.

Son œuvre a tout ce que j'aime. C'est original, c'est graphique, il y a de la couleur et de l'humour, c'est personnellement symbolique d'une façon qui est bizarrement communicable et qui correspond parfaitement à Gary lui-même. Gary est ce mélange fascinant de quelque chose de profondément sardonique et de complètement ouvert et encourageant. Il reste parfois chez moi lorsqu'il est de visite à Los Angeles et il est toujours 100 % enthousiaste et excité à propos de nous deux (et de toute autre personne présente éventuellement) pour sortir des presses de Gocco et faire du Goccoage ensemble. Tout le monde est bienvenu. L'art n'est pas précieux pour lui, mais

il est sacré, ce qui n'est pas la même chose. Son désir de partager cette excitation à propos de l'art est touchante. C'est beau de voir à quel point son attention envers l'art est constante. Le coté sardonique surgit avec les gens qui pensent que l'art va de soi. Demandez-lui de faire quelque chose gratuitement et dites lui qu'il doit le faire « pour se faire connaitre » et voyez ce qui va se passer. Et pourtant il a travaillé sans relâche et avec dévouement pour moi et mon album pour *Smilers* pour une somme que je peux vous dire ne représente qu'une fraction de la valeur réelle. Il va se sacrifier au nom de l'art, il va mettre son costume et aller au rendez-vous avec enthousiasme au nom de l'art mais si vous le traitez sans le respect qui lui est dû, il vous enverra vous faire foûtre.

Il y a une poignée de personnes dans ma vie qui me rappellent ce qu'est vraiment l'art. Vous l'oubliez parfois. Et d'autres fois il faut un chien de garde devant la porte pour veiller à ce qu'il ne soit pas traité à la légère. Et puis vous franchissez la porte et vous vous souvenez que la vie a un sens et que nous sommes tous interconnectés et que c'est ainsi que nous protégeons cette connexion. Vous la protégez en le faisant constamment, en partageant, en l'enseignant aux autres, en vous battant contre ceux qui vont s'en défaire pour la dévaluer et en diminuer la valeur en lui enlevant toute sa magie. Gary est le chien de garde. Il vous aime, d'accord ? Vraiment. Il suffit de regarder. Vous allez voir.

PREFAZIONE

Aimee Mann

Mi ricordo di quando ho cominciato a pensare di voler fare musica. In realtà non ero ancora una musicista, ma solo una ragazzina che cercava di replicare con la chitarra le canzoni di altra gente. Giocavo con l'idea di provare a scrivere le mie di canzoni e pensavo a come sicuramente ogni possibile combinazione di sequenze di accordi e melodie fosse già stata creata, e a come si fosse esaurita la scorta di nuove idee nel mondo. E allora, com'era possibile per me creare qualcosa di nuovo, interessante e diverso?

Ancora adesso qualche volta ho lo stesso atteggiamento verso le belle arti. Dal momento che non dipingo né disegno, o meglio, dal momento che lo faccio da assoluta principiante, non ho mai assorbito la tecnica al punto di farla diventare parte di me e un modo per tradurre quello che mi passa per la testa. Così sono sempre un po' scioccata quando m'imbatto in qualcosa che mette totalmente in discussione questo modo di pensare.

La prima volta che ho visto il lavoro di Gary era il 2007, in una piccola galleria d'arte vicina a dove vivo chiamata La Luz de Jesus. Non è una galleria d'arte in senso stretto, ma piuttosto un insieme di libreria/negozio di oggettistica, il tipo di posto dove si vendono libri su tatuaggi, auto e omicidi, tavole spiritiche, e bambole e giocattoli strani. Lo spazio espositivo è nel retro. Stavo pensando alle immagini da usare per la copertina del mio nuovo album. Volevo qualcosa che si ispirasse alla progettazione grafica, alla cartellonistica e alle immagini pubblicitarie e cose del genere. (Ho una collezione di annuari della *Graphis* che amo molto; me l'ha data mio padre che lavorava nel campo della pubblicità). In questa galleria c'erano diverse cose che mi hanno colpita: un paio d'immagini erano tipo quelle dei fumetti – una in particolare mi aveva quasi convinta. E poi ho girato l'angolo e ho visto le cose di Gary ed è stata come una folgorazione. Era quello cercavo!

Mi piace tutto nelle sue opere. Sono originali, hanno l'elemento forte della grafica, colore, umorismo, sono simbolici (ti ci puoi stranamente identificare) ma anche molto personali al tempo stesso. Riflettono bene la personalità dell'artista. Gary è questa combinazione affascinante di profondamente sardonico e completamente aperto e incoraggiante. Viene da me qualche volta quando passa da Los Angeles, ed è sempre entusiasta al cento per cento, tutto emozionato di mettersi a stampare con me (e chiunque altro ci sia in giro) con il sistema Gocco e a "goccare" un po' insieme. Tutti sono i benvenuti nel processo artistico. L'arte non è una cosa preziosa per lui, ma è sacra, che è una cosa diversa. La sua disponibilità a condividere con altri l'entusiasmo per l'arte è toccante, così come è toccante la devozione che mette in quello che fa. Il suo lato beffardo viene fuori quando la gente dà l'arte per scontata. Chiedigli di fare qualcosa gratuitamente per farsi pubblicità e guarda come reagisce. E comunque per me ha lavorato senza sosta alle immagini per l'album *Smilers* per una cifra che è solo una frazione di quello che vale. Gary si sacrifica per l'arte, è preparato ed entusiasta, ma se manchi di rispetto alla sua missione, allora te la fa pagare.

Nella mia vita c'è un gruppo di persone che mi ricorda che cosa l'arte sia veramente. Qualche volta lo si dimentica. E qualche volta c'è bisogno di un cane da guardia al cancello per assicurarsi che l'arte non venga presa alla leggera. E quando poi passi per quel cancello ti ricordi che la vita ha un significato e che siamo tutti collegati, e che l'arte è il modo di proteggere quel collegamento. E allora se ne deve produrre costantemente, condividerla, insegnarla, lottare contro quelli che vogliono svenderla, svalutarla e spogliarla della sua magia. Gary è il cane da guardia. Ti vuole bene, ok? Davvero, fidati. Dai un'occhiata. Te ne renderai conto da solo.

PRÓLOGO

Aimee Mann

Recuerdo cuando comencé a pensar en tocar música. Ni siquiera era realmente un músico: solo un niño intentando aprender las canciones de otros en la guitarra. Pensaba en la idea de intentar escribir canciones, y en que, seguramente, ya se habían compuesto todas las combinaciones posibles de progresión armónica y melodía y, además de todo, no hay nada nuevo bajo el sol, así que en realidad, ¿cómo es siquiera posible crear algo nuevo, interesante y diferente?

Todavía, a veces, conservo esa actitud frente a las bellas artes. Como no pinto ni dibujo, o más bien, como pinto y dibujo exclusivamente en un sentido pasatista y amateur, nunca llegué al punto en el que se toma la forma y se la absorbe de modo que se transforma en una manera de traducir lo que está en tu cabeza. De modo que siempre me sorprendo cuando me encuentro con algo que me hace reconsiderar totalmente esa postura.

La primera vez que vi la obra de Gary fue en 2007, en una pequeña galería próxima a donde yo vivía, llamada "La Luz de Jesús. " No es una galería propiamente dicha sino parte de una tienda de libros/chucherías, el tipo de lugar que tiene libros de tatuajes, automóviles, asesinatos, güijas, y juguetes y muñecos extraños. Al fondo hay una galería. Estaba pensando vagamente en lo que deseaba para el diseño gráfico de mi próximo álbum. Sabía que quería algo bien visual, porque me encantaba el arte gráfico y los pósteres y los diseños publicitarios y cosas por el estilo. (La colección de viejos

Anuarios de Graphis que heredé de mi padre, que trabajaba en publicidad, es un tesoro para mí.) Había algunas cosas en esa galería que me gustaban. Uno o dos artistas estaban haciendo algo así como una historieta y, de hecho, estaba considerando a uno en particular cuando, al doblar una esquina, vi el trabajo de Gary, y fue como... BUM. Es este.

Su obra tiene todo lo que a mí me gusta. Es original, es gráfica, tiene color y humor; y curiosamente, su simbolismo, si bien personal, permite sentirse identificado, además de reflejar mucho a Gary. Gary es una combinación fascinante de lo profundamente sardónico y lo totalmente abierto y alentador. Cuando visita Los Ángeles, a veces se queda en casa, y siempre se muestra absolutamente entusiasmado y emocionado de usar (nosotros dos y cualquier otra persona que esté con nosotros) la imprenta Gocco y hacer impresiones juntos. Todos son bienvenidos. Para él, el arte no es algo "precioso", pero sí sagrado, que no es lo mismo. Su deseo de compartir su entusiasmo por el arte es conmovedor. Es hermoso ver lo constante que es su atención hacia el arte. El aspecto sardónico sale a relucir con la gente que da el arte por sentado. Pídele que haga algo gratis y dile que lo tiene que hacer "para lograr exposición"; verás lo que sucede. Y, sin embargo, trabajó incansablemente y con devoción para el diseño gráfico de mi álbum *Smilers,* por lo que, sin duda alguna, es una ínfima parte de lo que realmente vale. Se sacrifica por el arte, se vestirá de traje y se presentará a la cita con entusiasmo, pero si le faltas el respeto, te aniquilará.

Hay un puñado de gente en mi vida que me recuerda cuál es la verdadera esencia del arte. A veces, uno se olvida. Y a veces hace falta un perro guardián en la puerta para asegurarse de que no se lo degrade. Y luego uno atraviesa la puerta y recuerda que la vida tiene sentido, que todos estamos conectados, y que así protegemos esa conexión. Se lo protege haciendo arte todo el tiempo, compartiéndolo, enseñándolo, combatiendo a los que lo regalarían y devaluarían y enviciarían y le quitarían la magia. Gary es el perro guardián. Te ama, ¿sabes? Te ama de verdad. Échale un vistazo. Te darás cuenta.

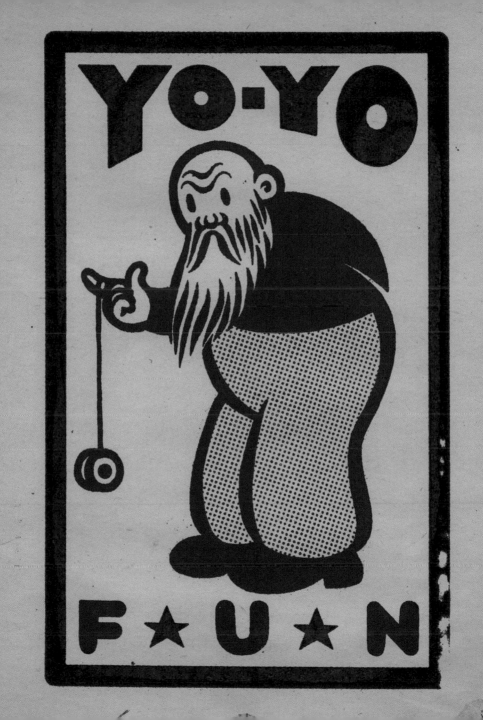

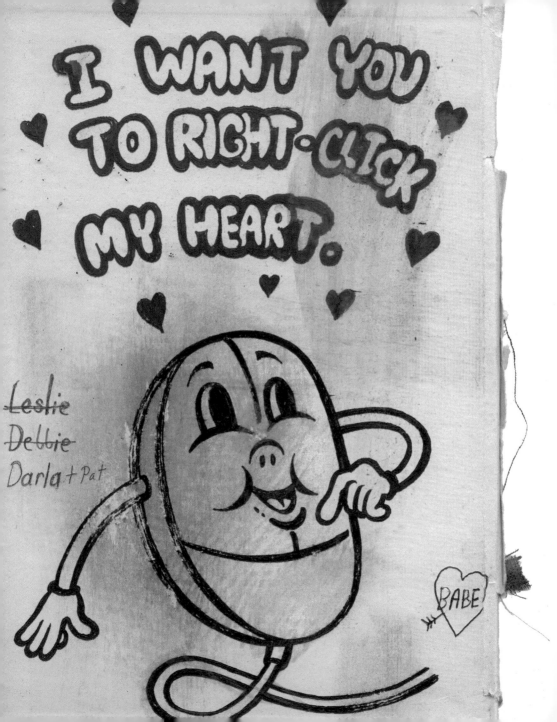

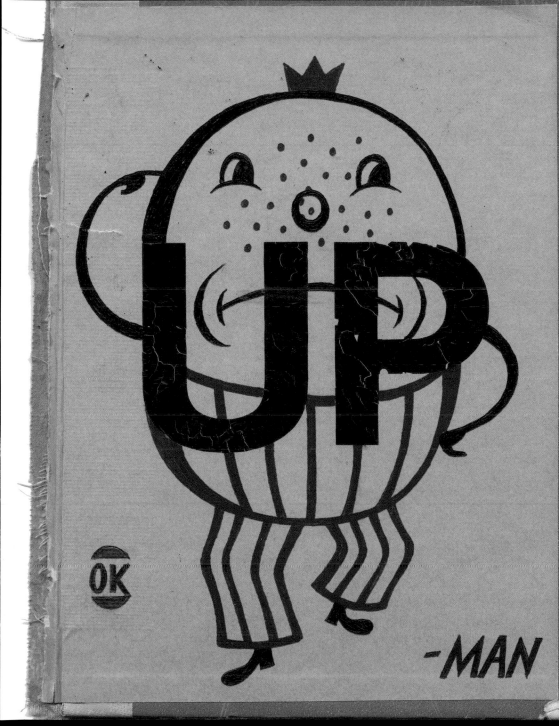

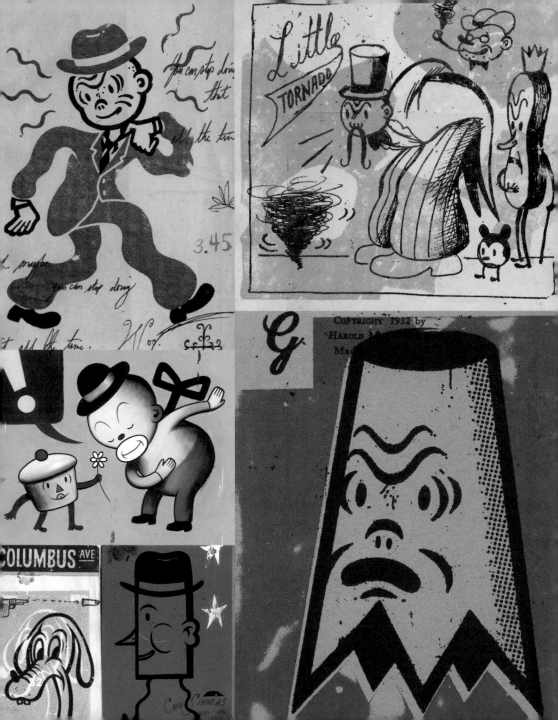

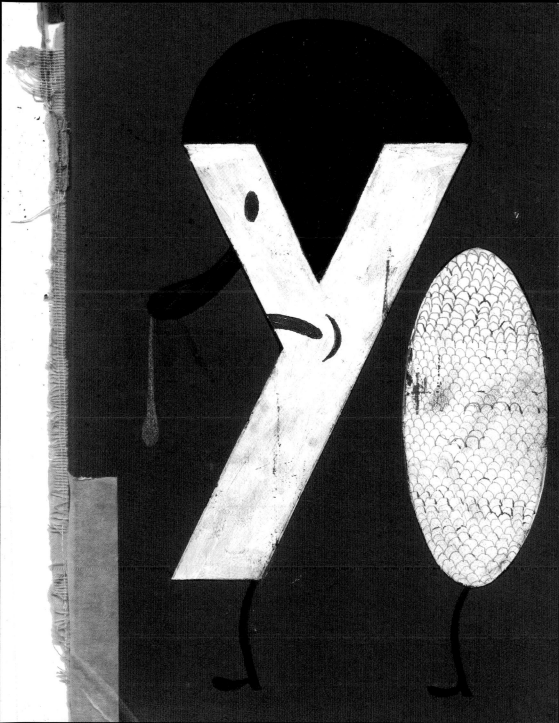

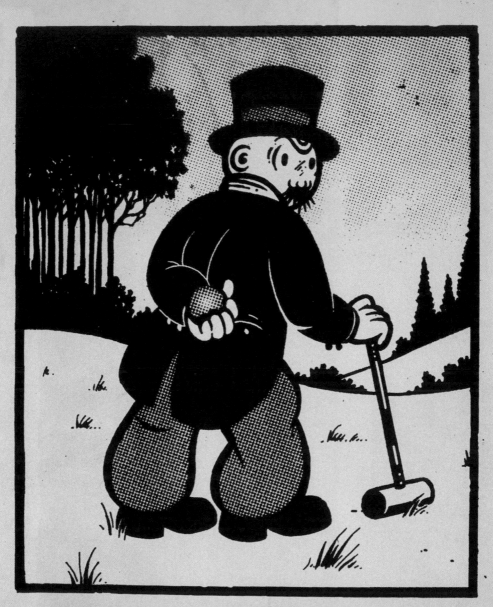

"Just then, the truth hit him - he would be nothing more than last year's winner."

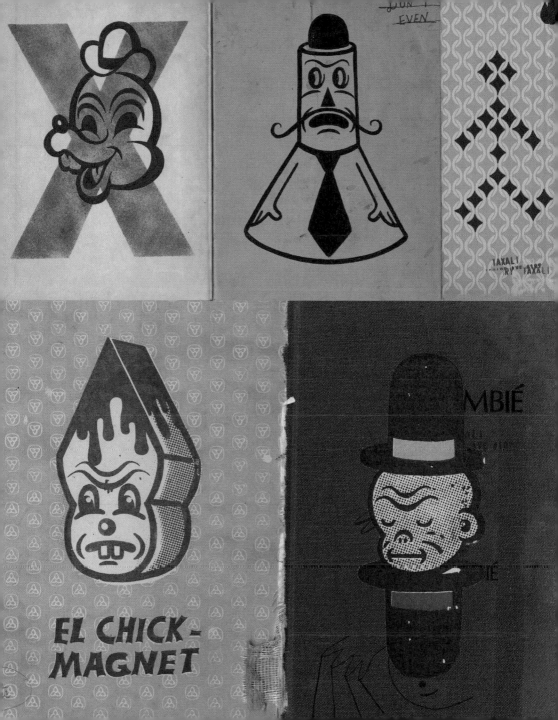

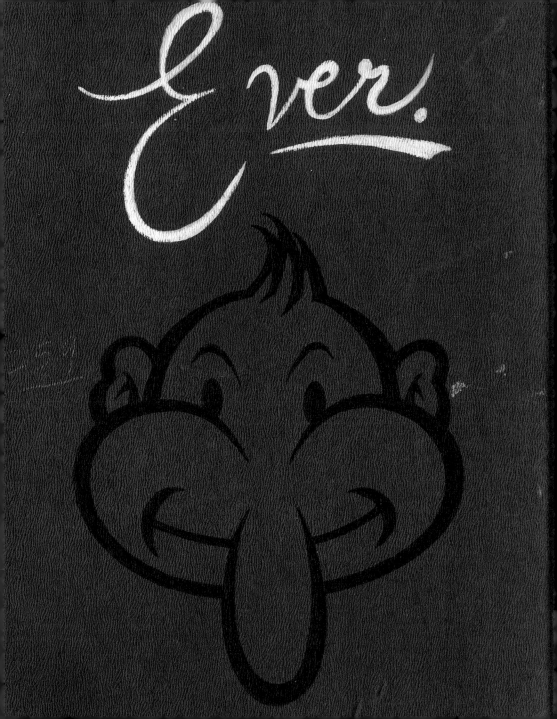

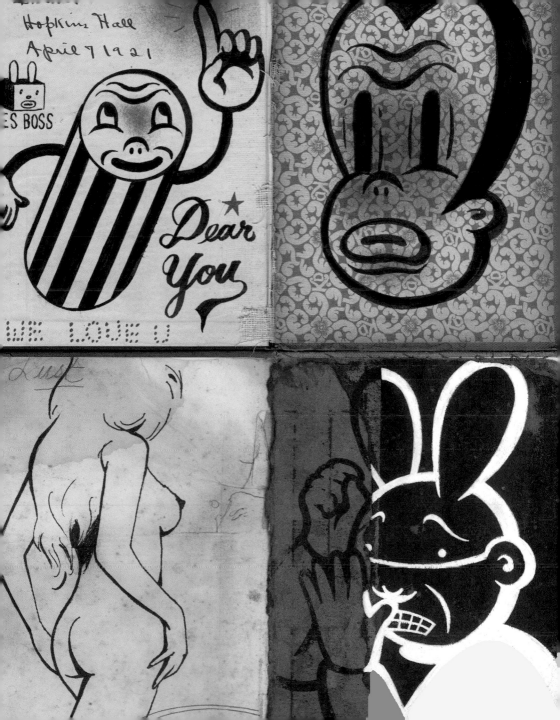

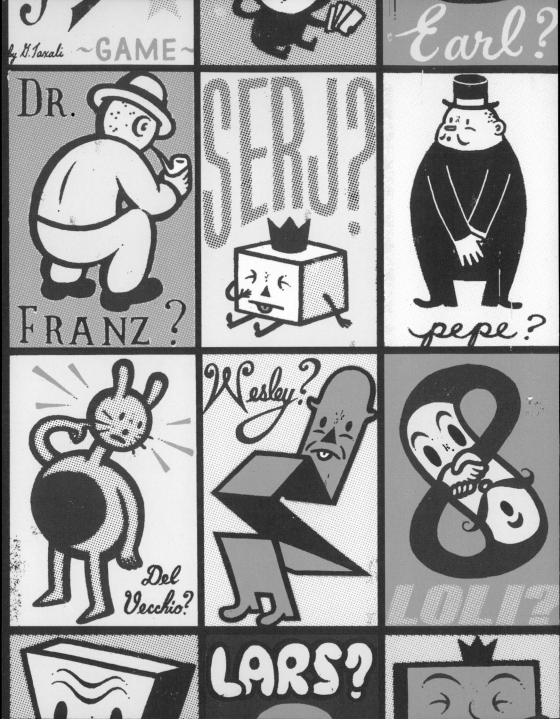

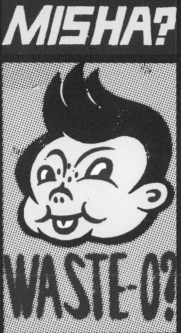
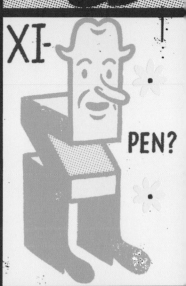
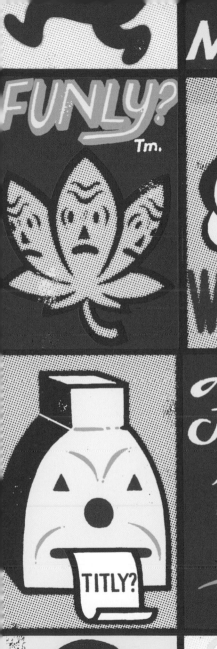
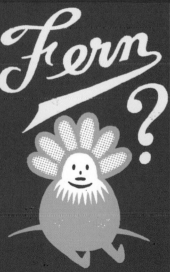
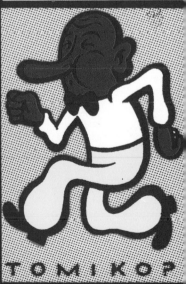

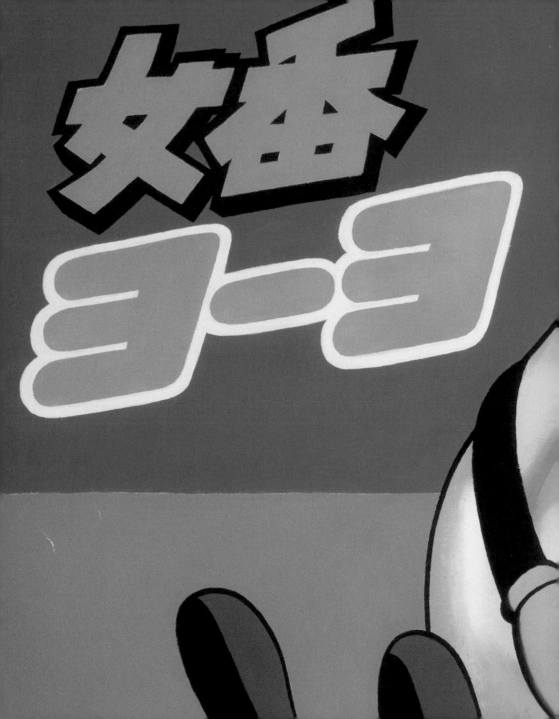

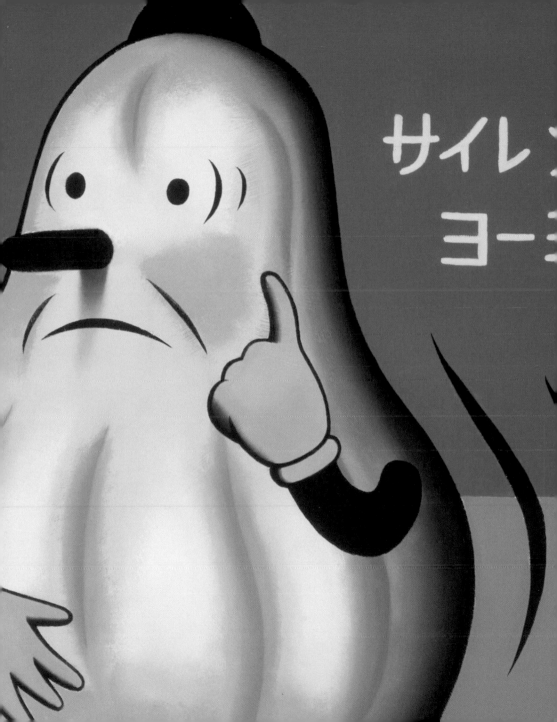

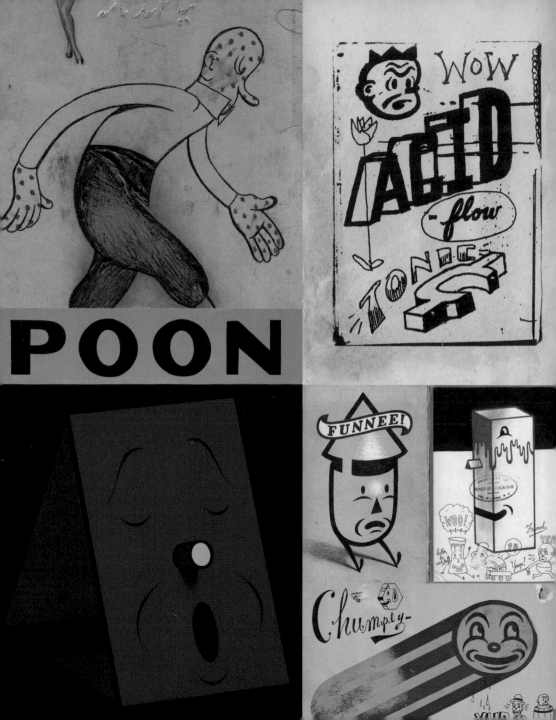

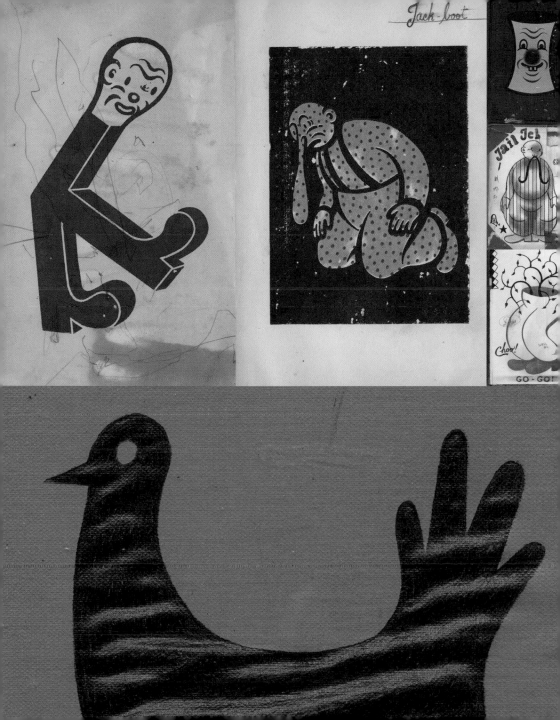

Jach-boot

Jail Jeh

Choo!

GO-GO!

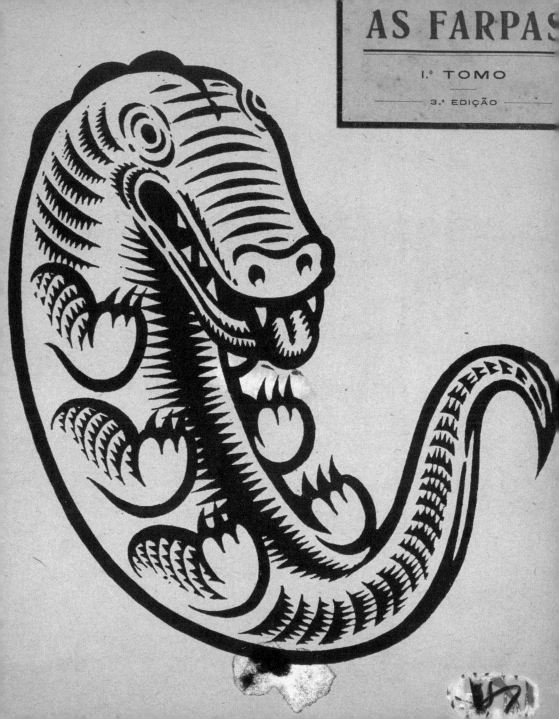

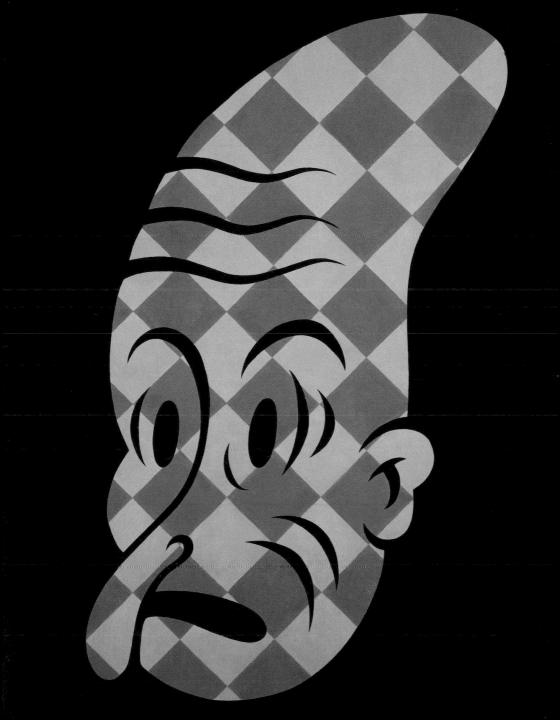

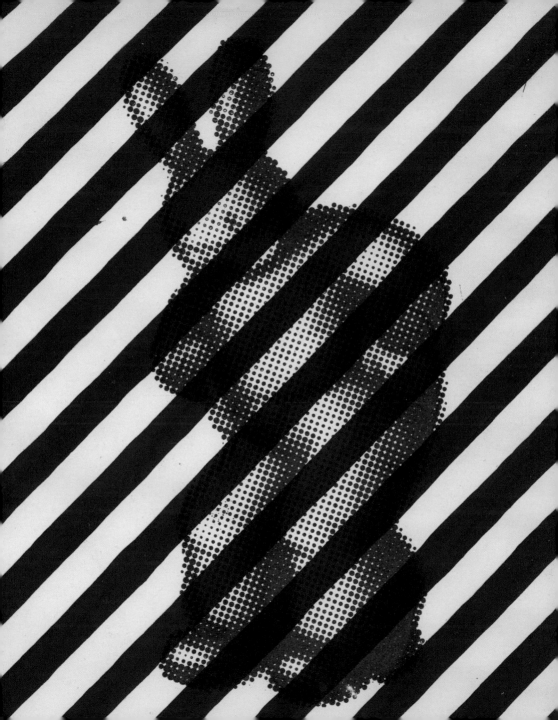

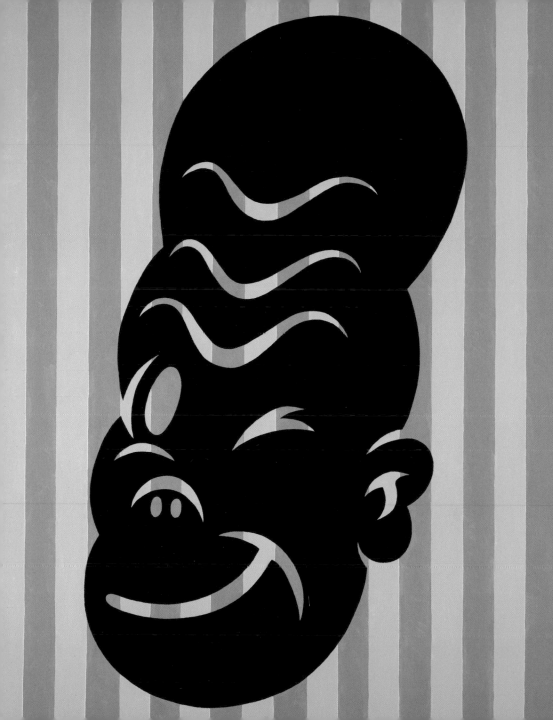

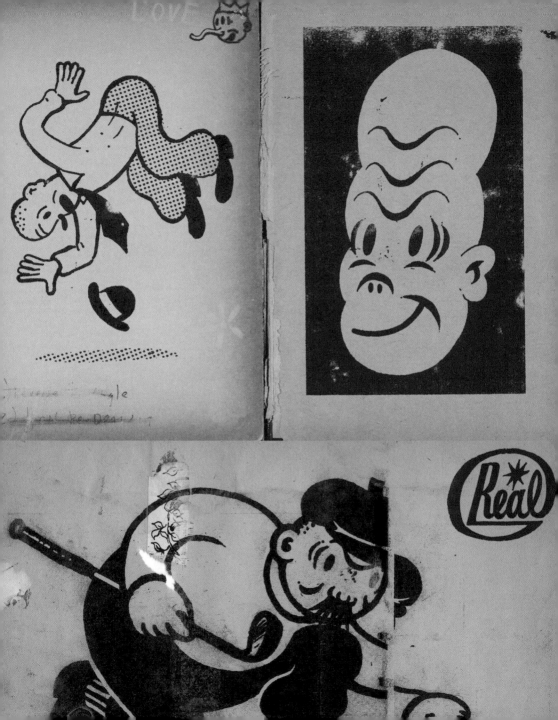

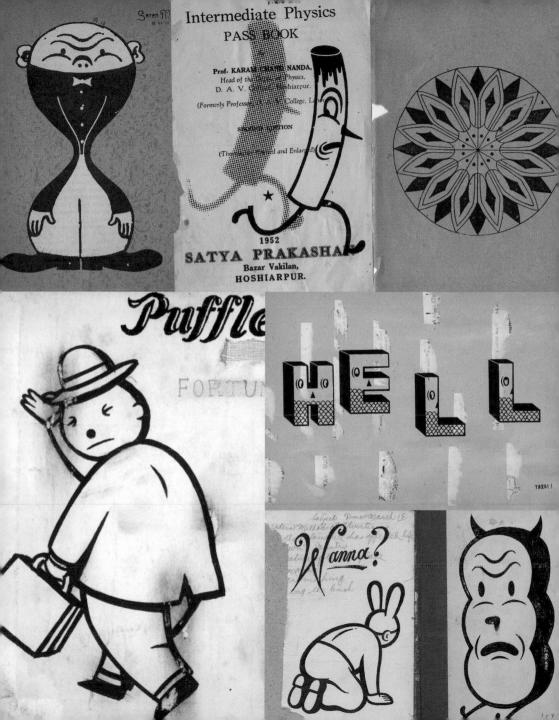

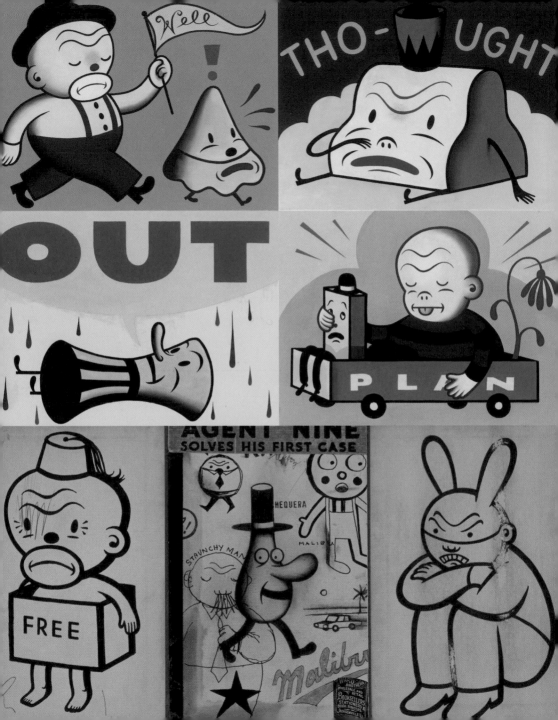

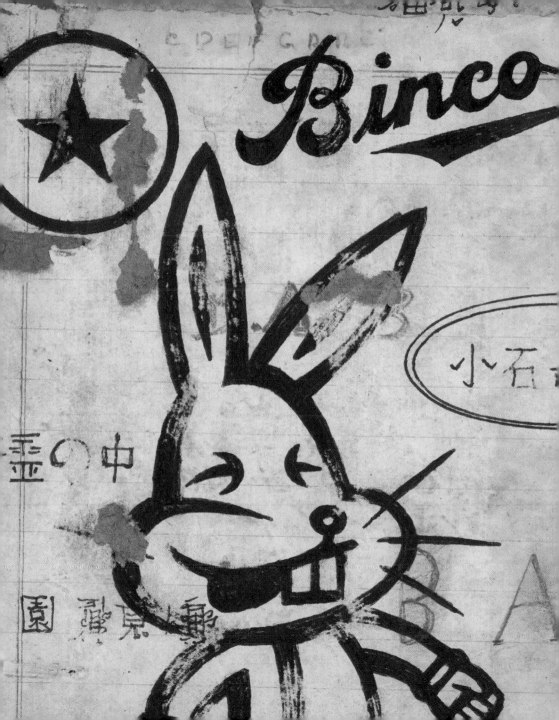

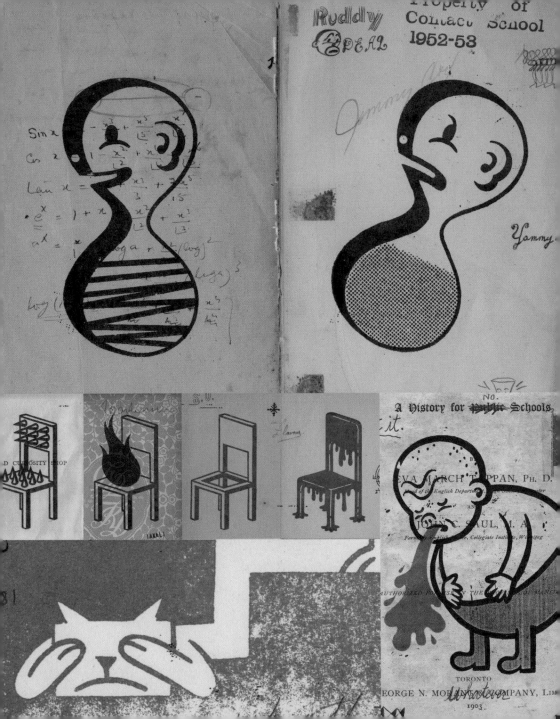

the language of the restless days

George C. Heron
E S. No 7
scarboro He[...]

June 7th 1901

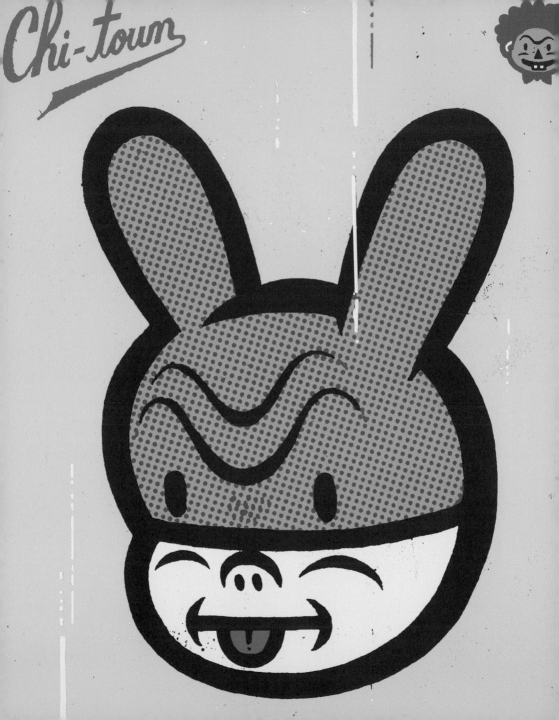

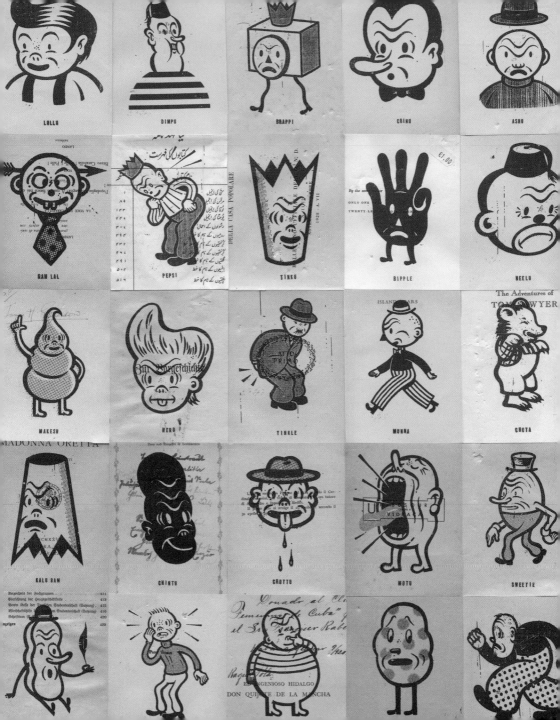

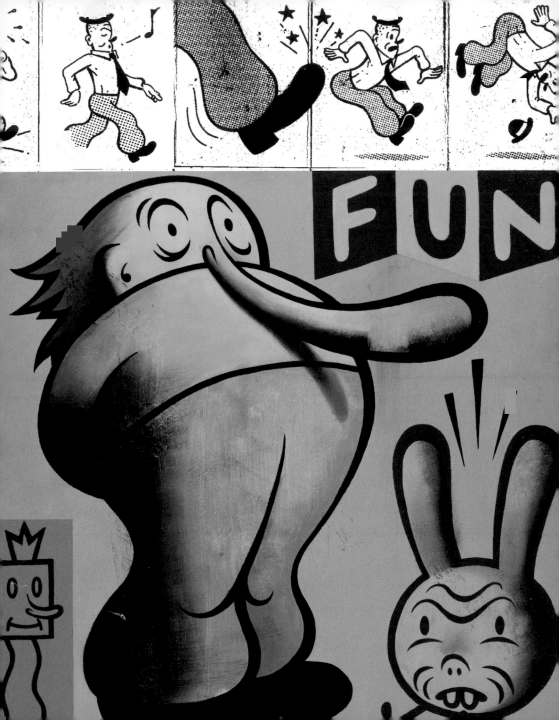

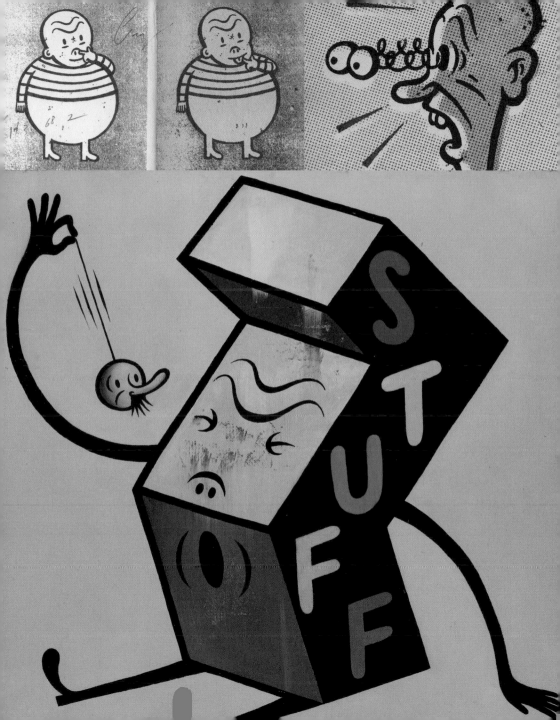

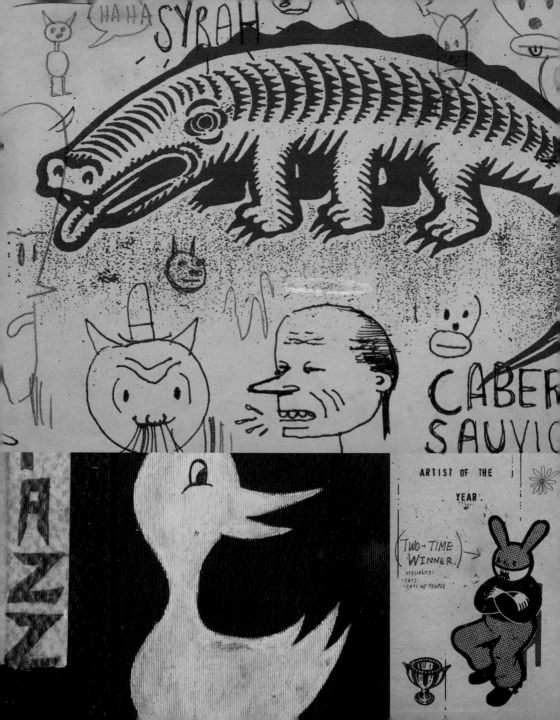

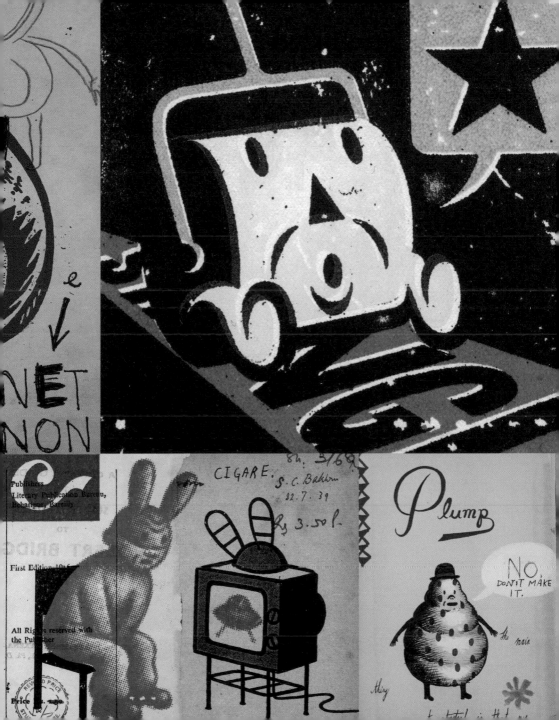

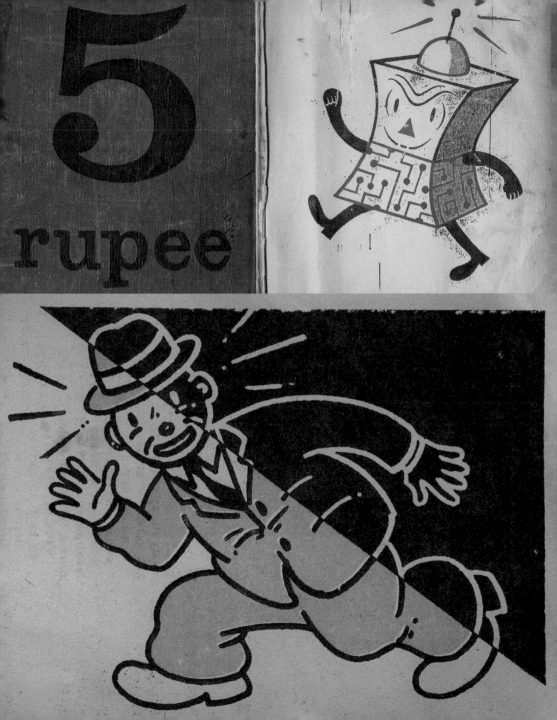

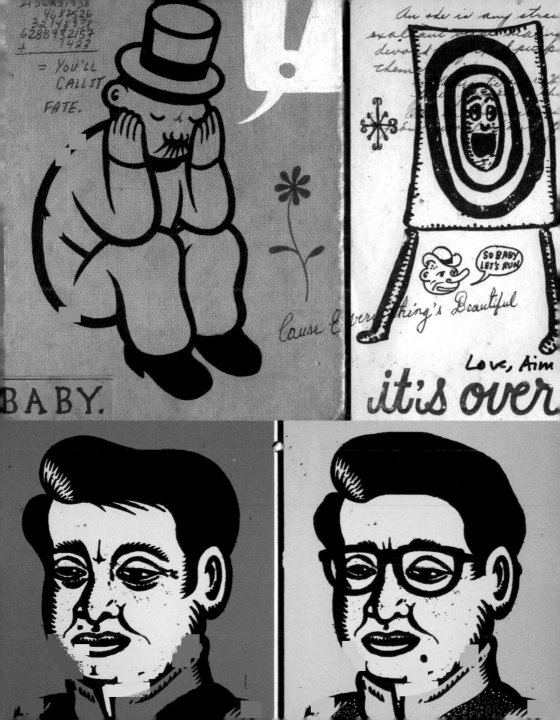

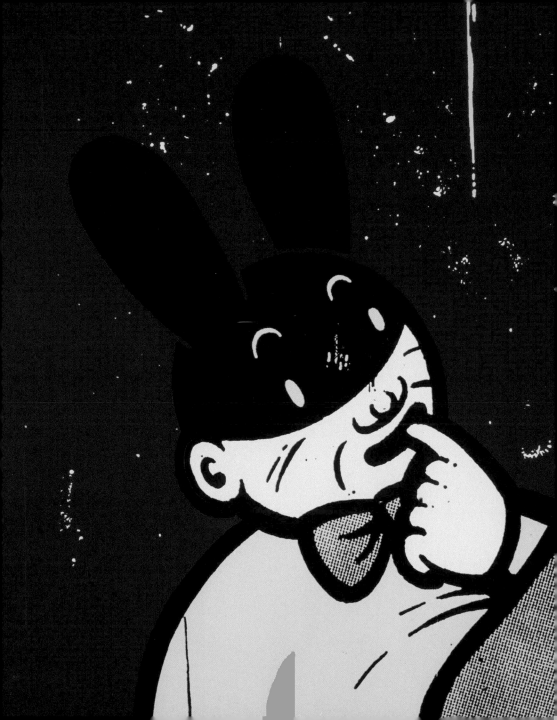

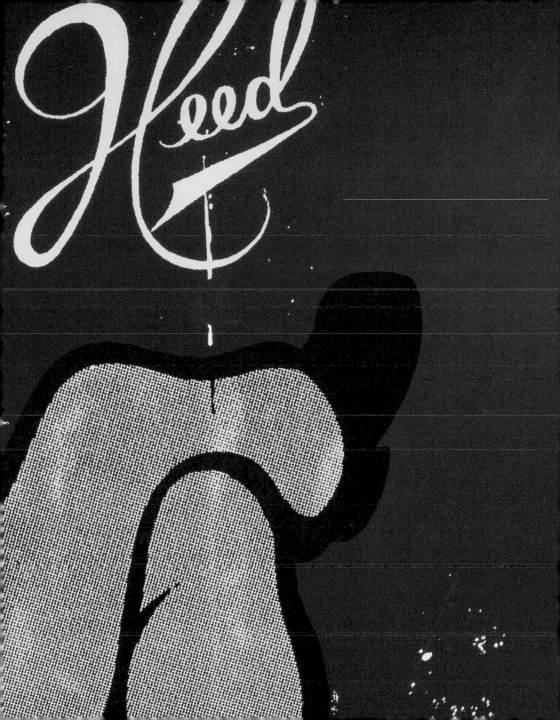

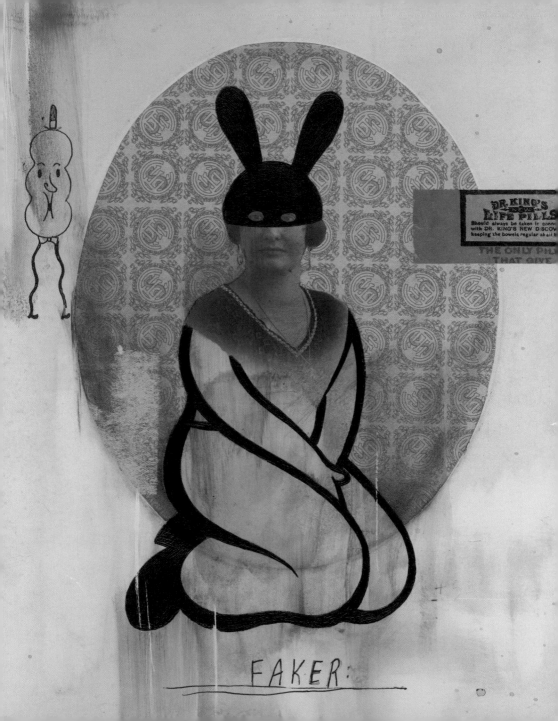

FAKER:

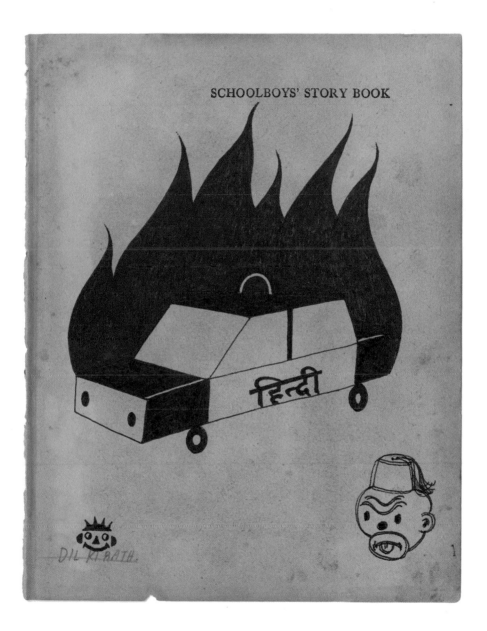

SCHOOLBOYS' STORY BOOK

हिन्दी

DIL KI BATH.

1

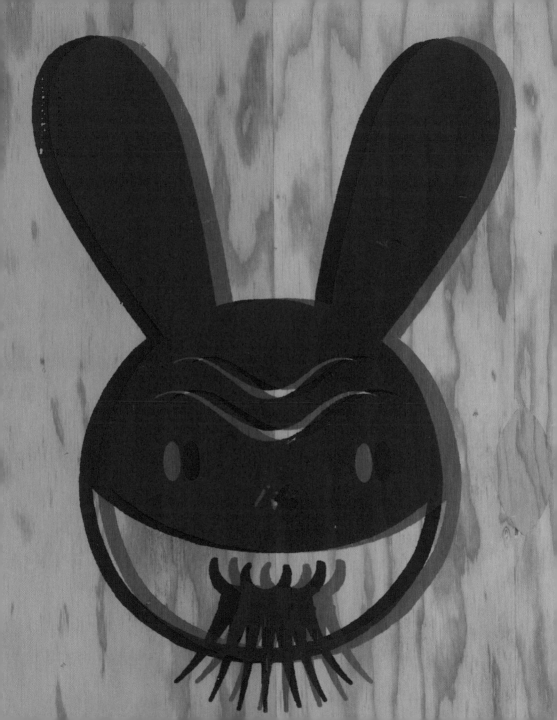

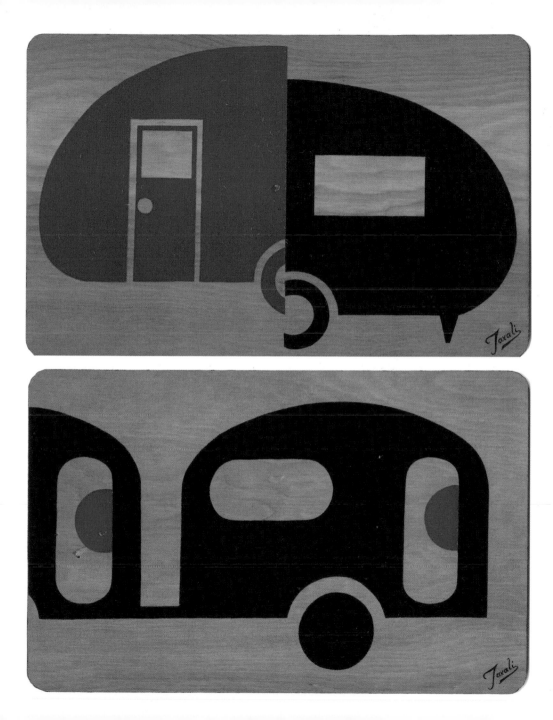

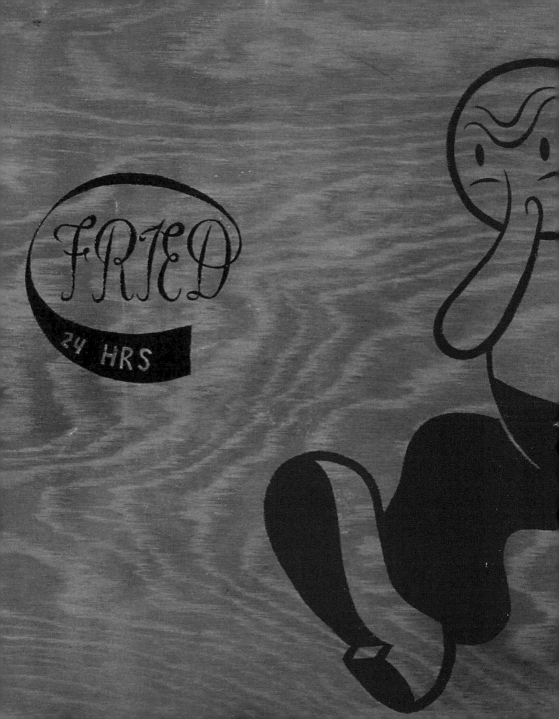

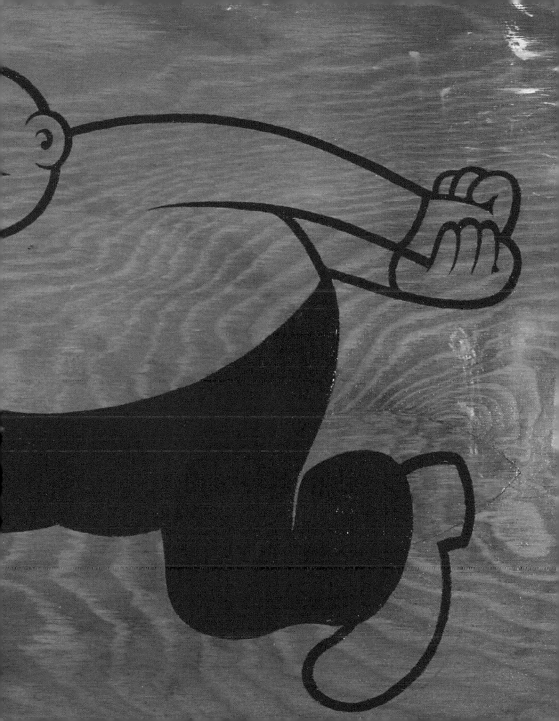

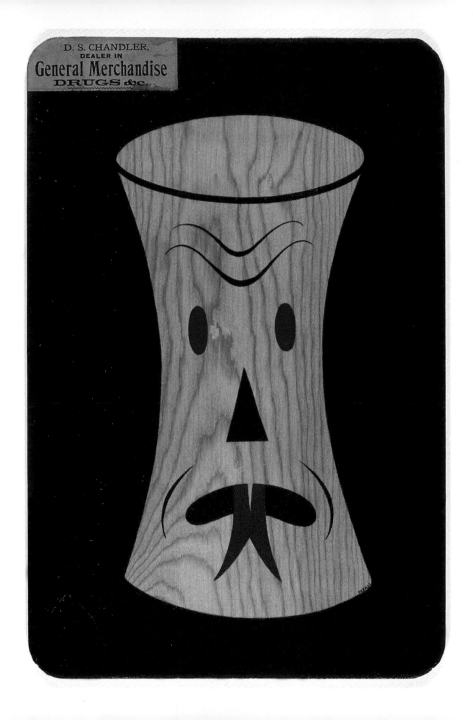

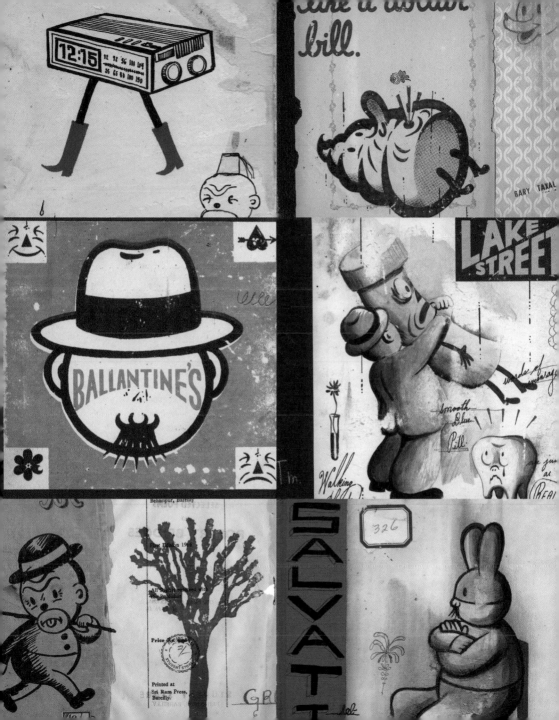

10·РУБ·10

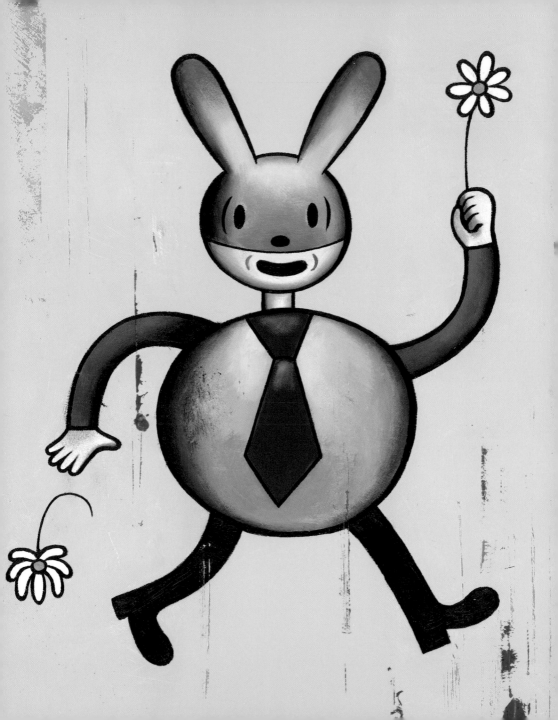

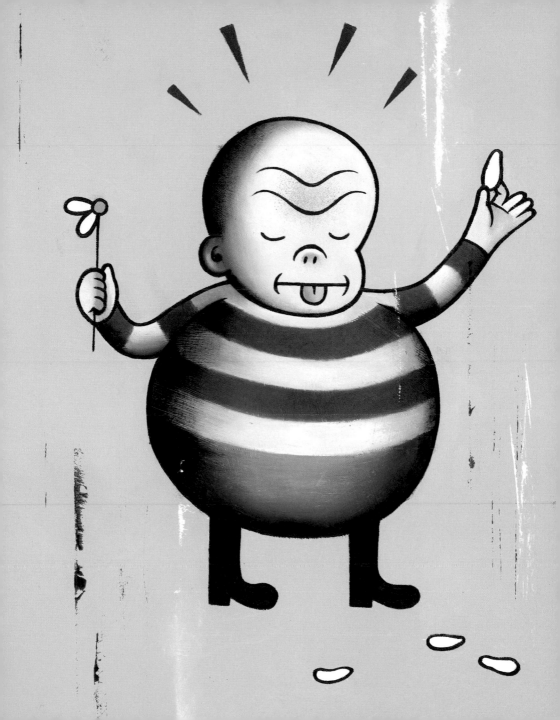

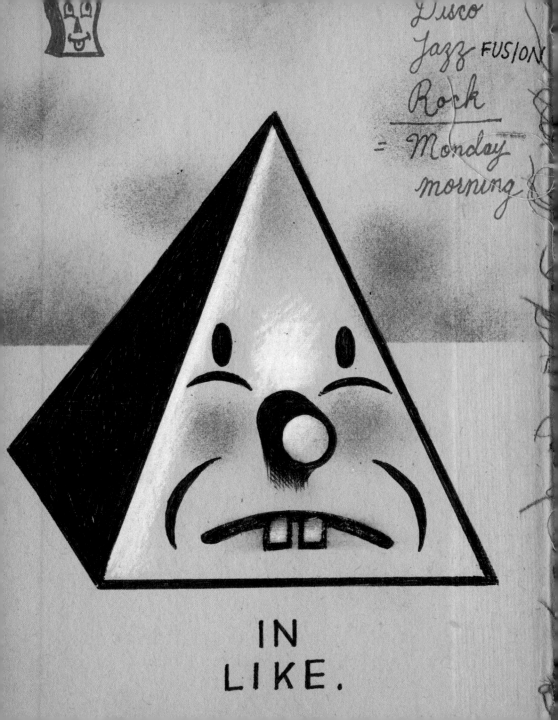

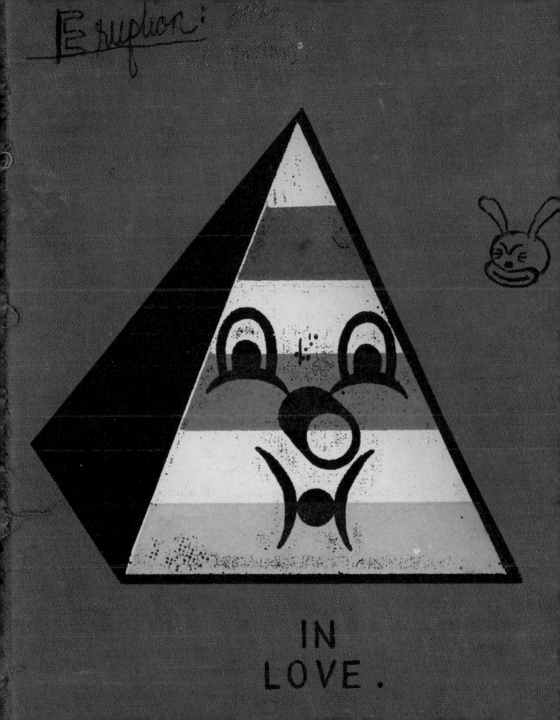

Eruption:

IN
LOVE.

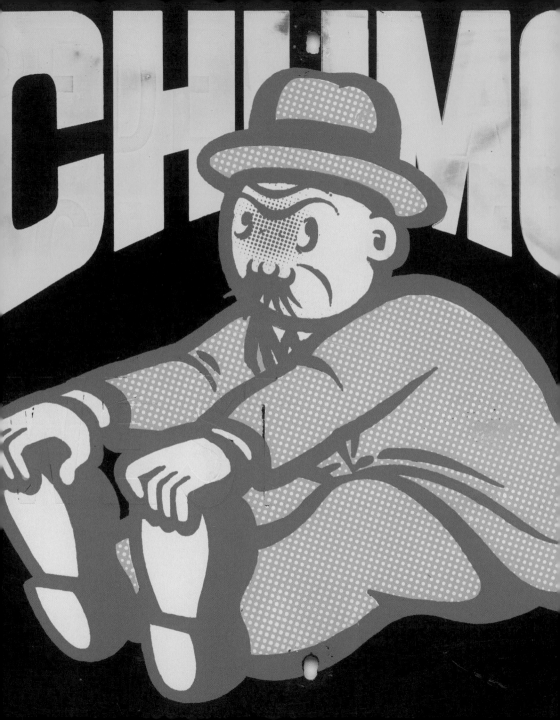

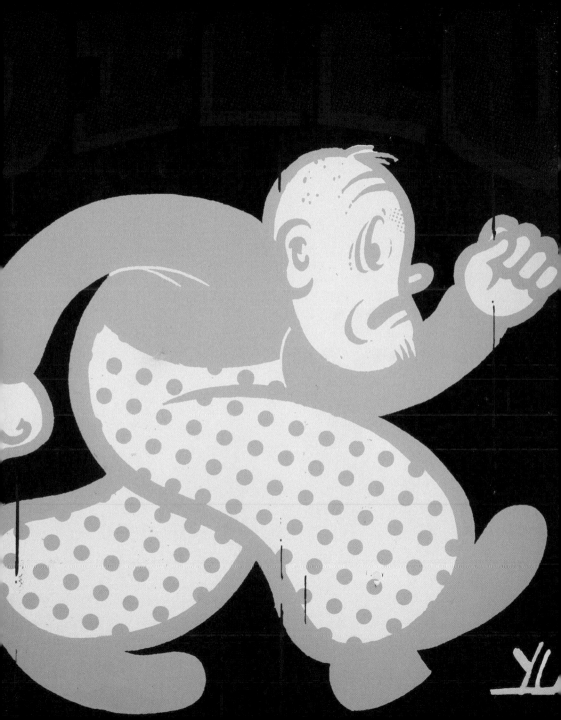

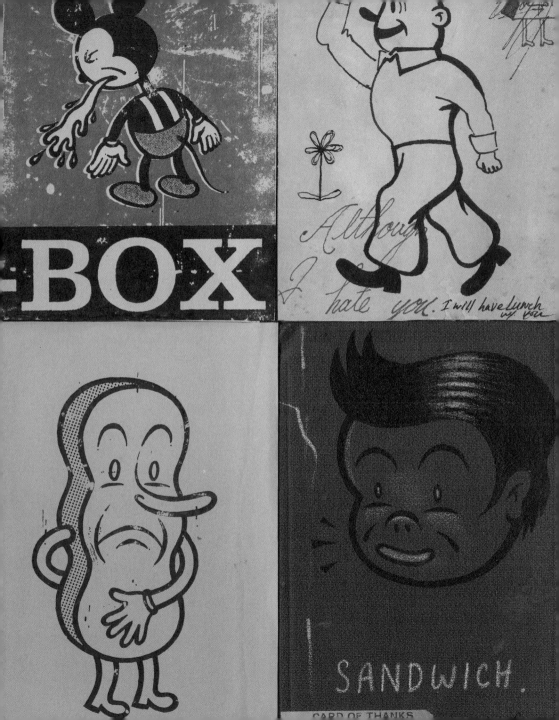

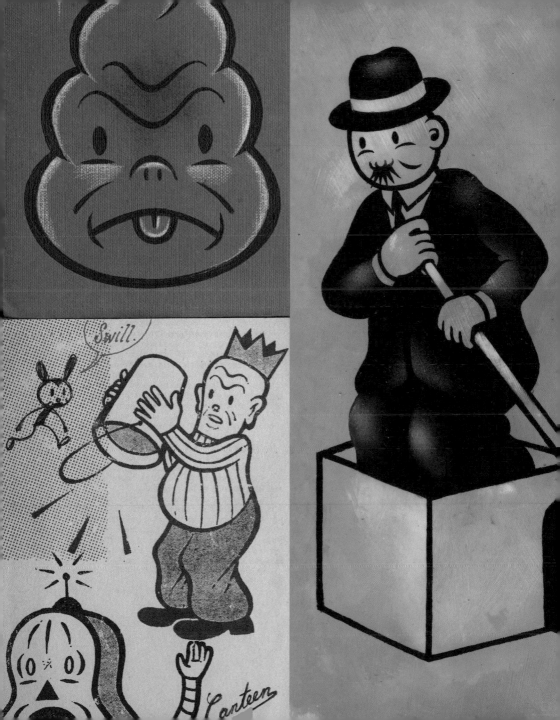

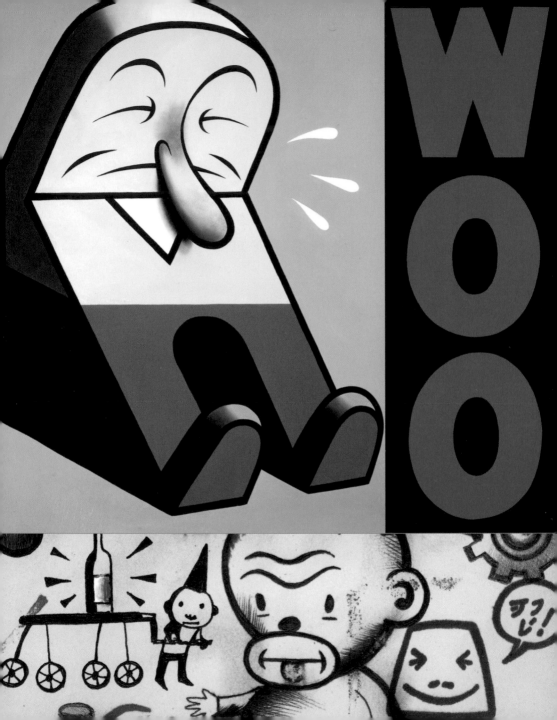

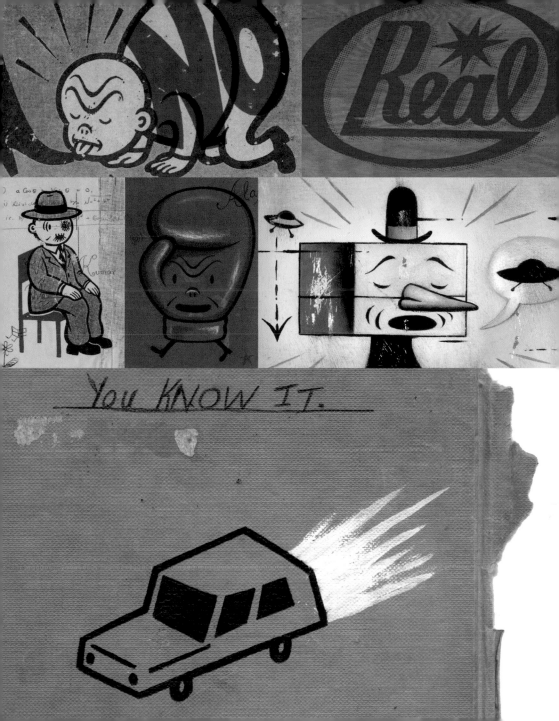

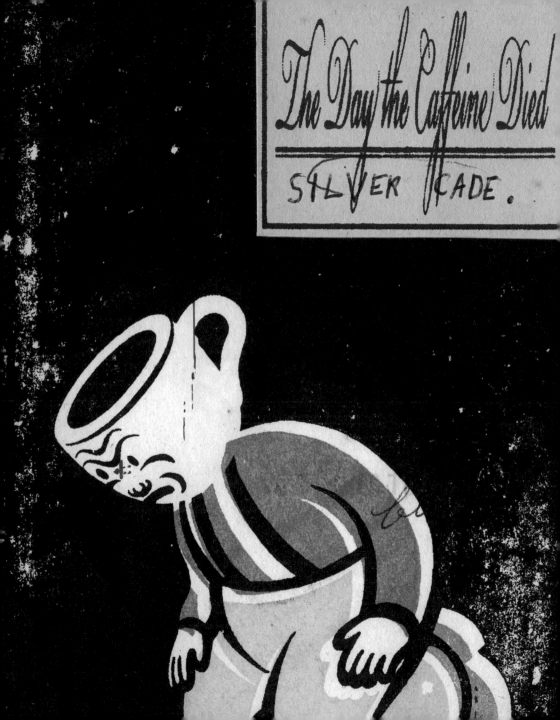

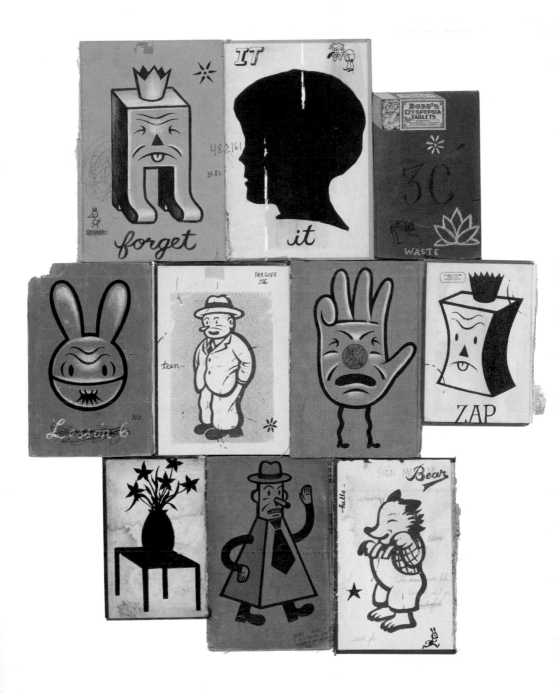

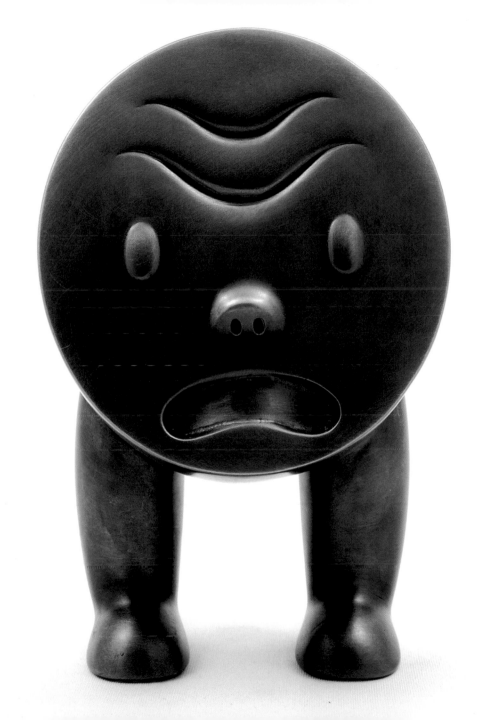

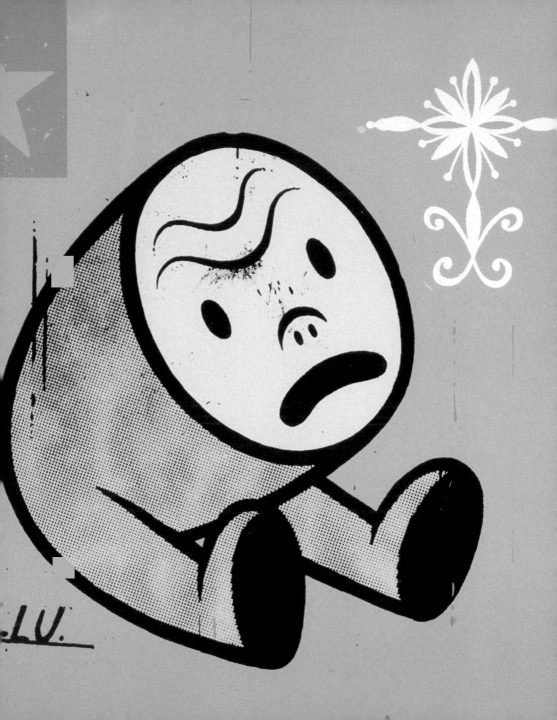

FUN
LY

HELL
YEAH.

TR
+ P
T

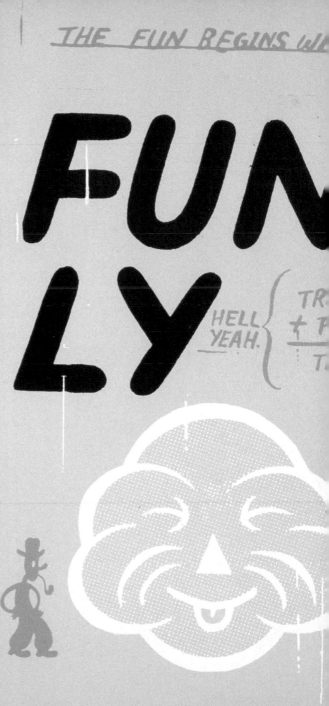

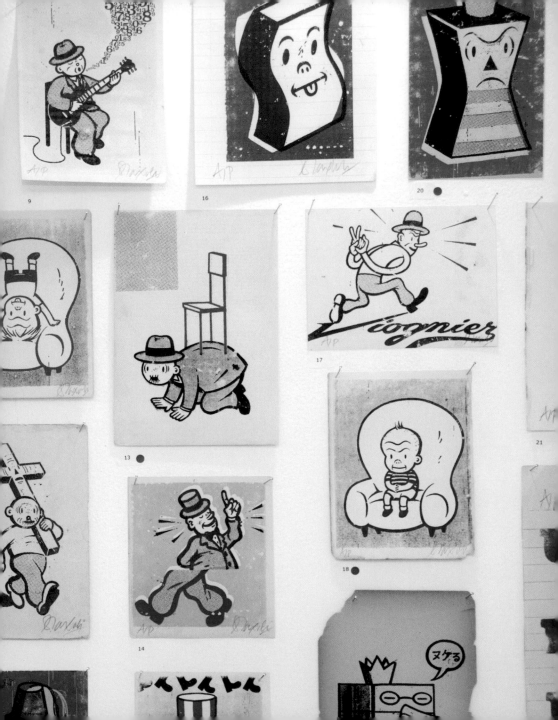

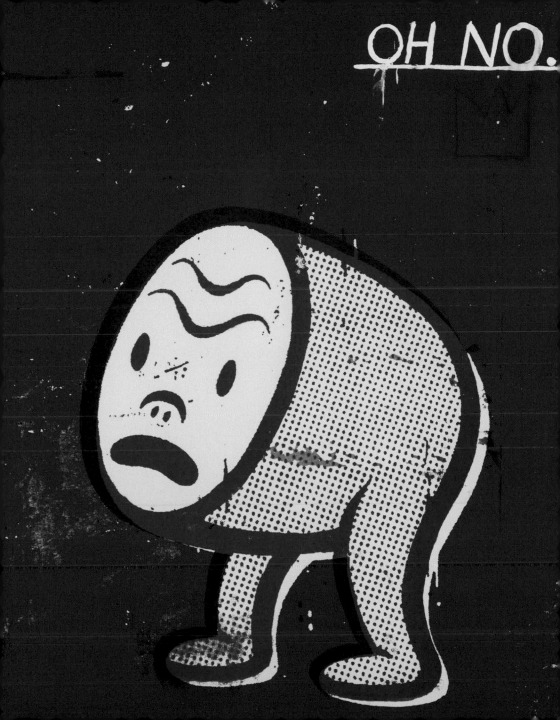

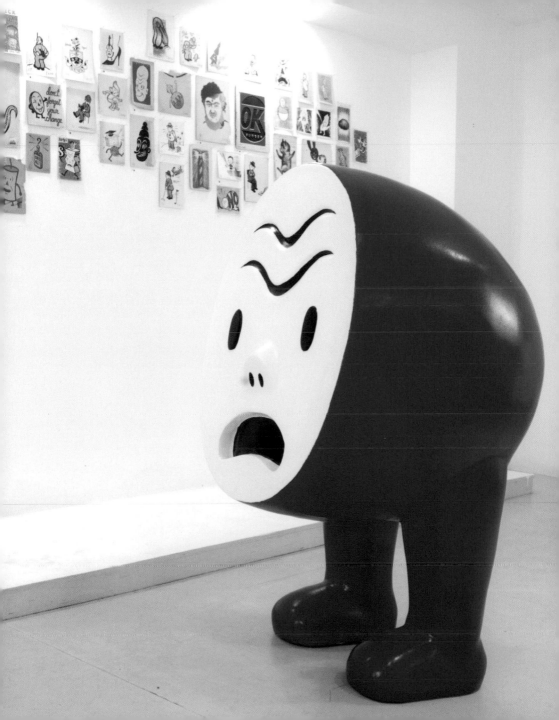

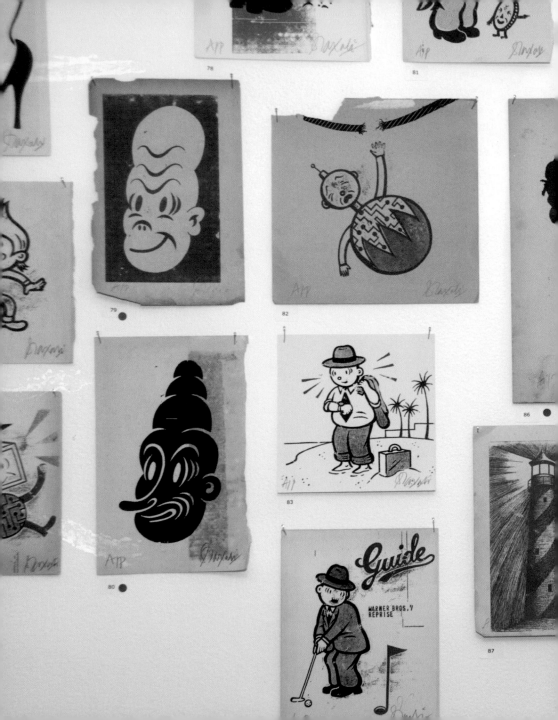

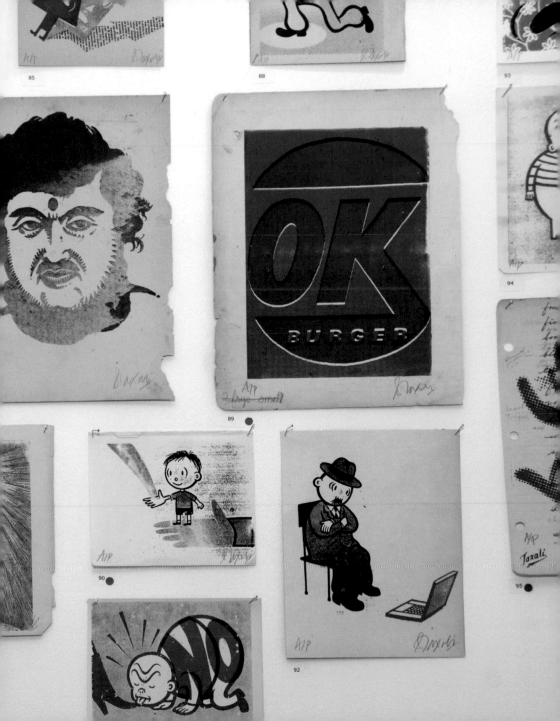

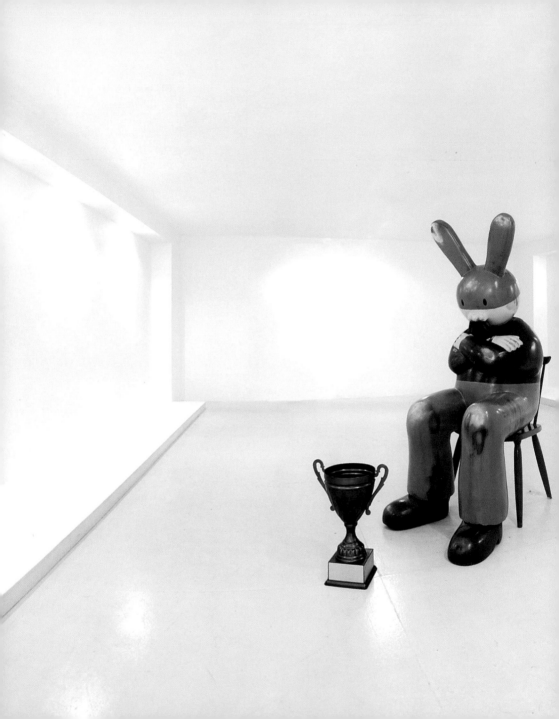

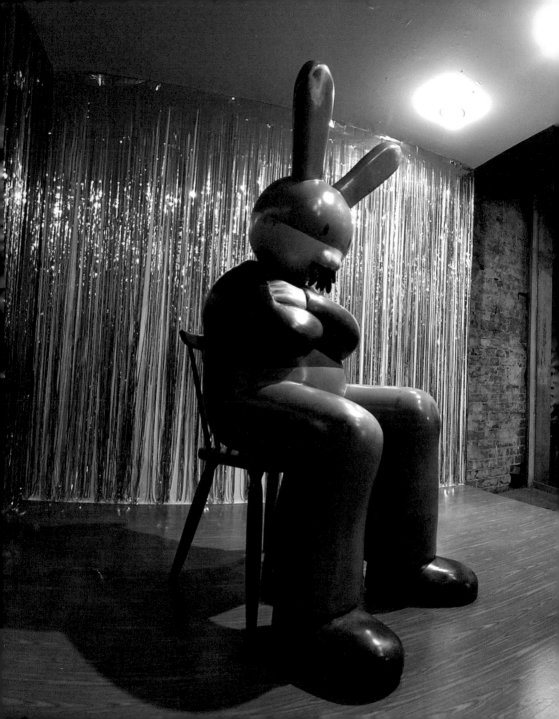

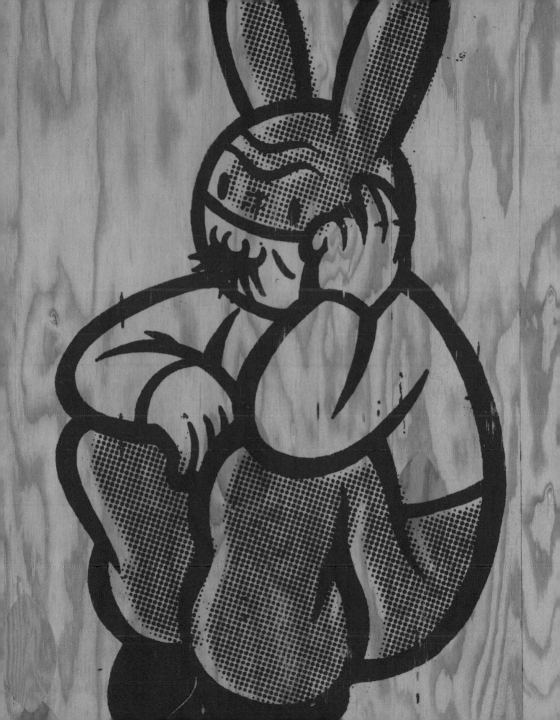

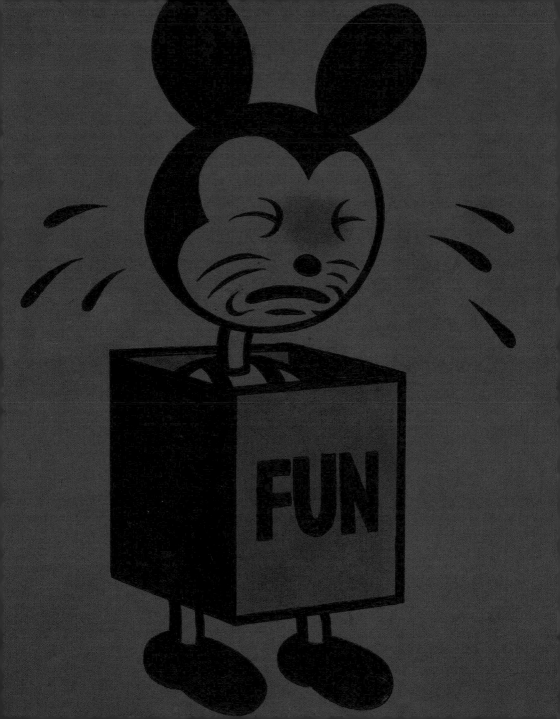

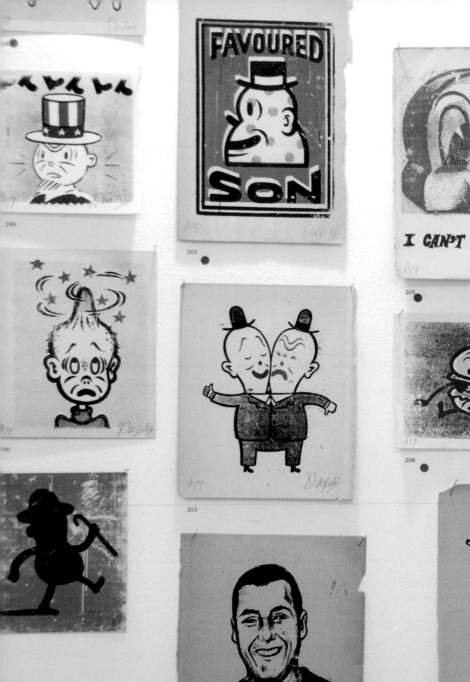
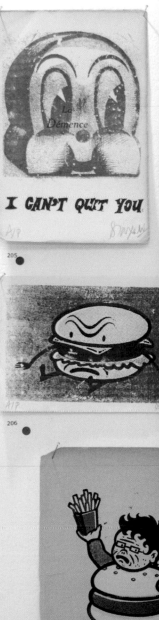

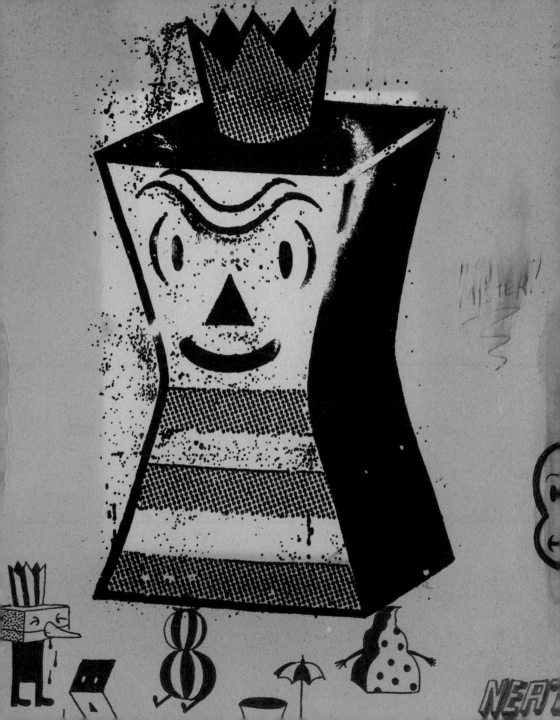

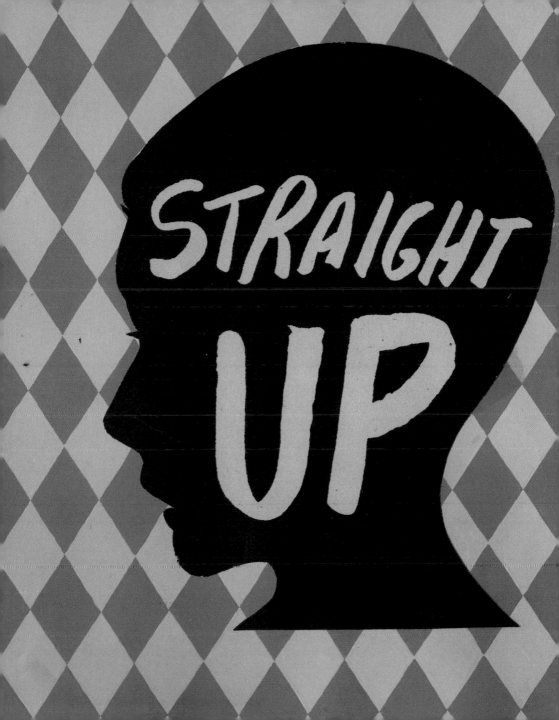

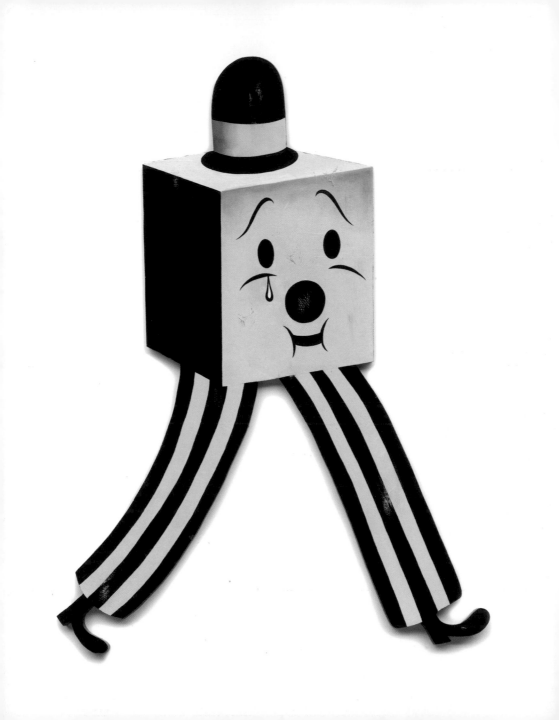

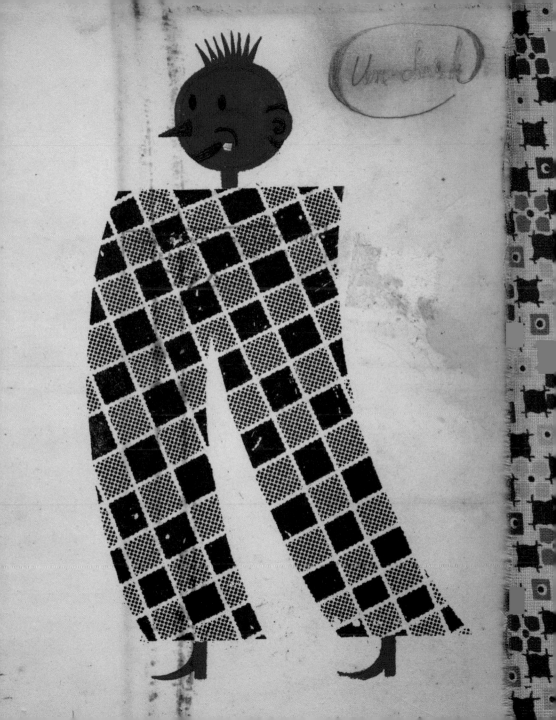

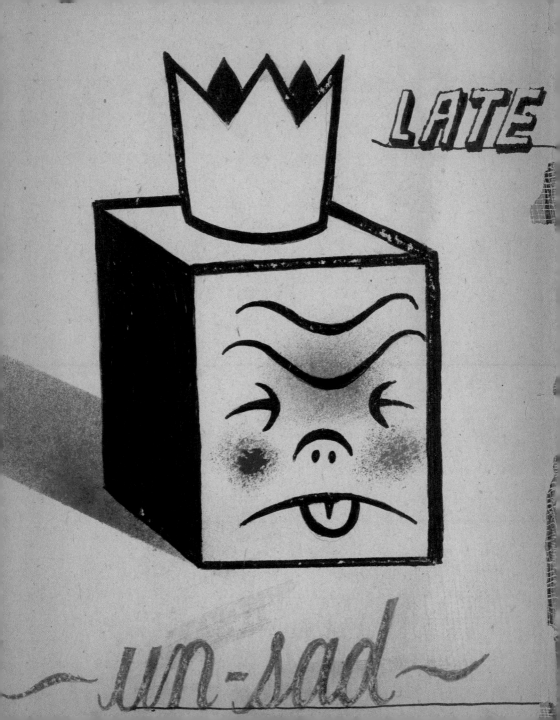

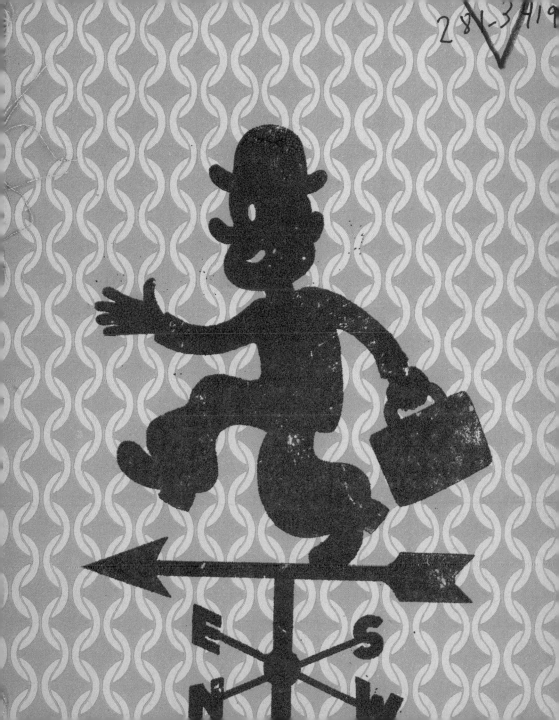

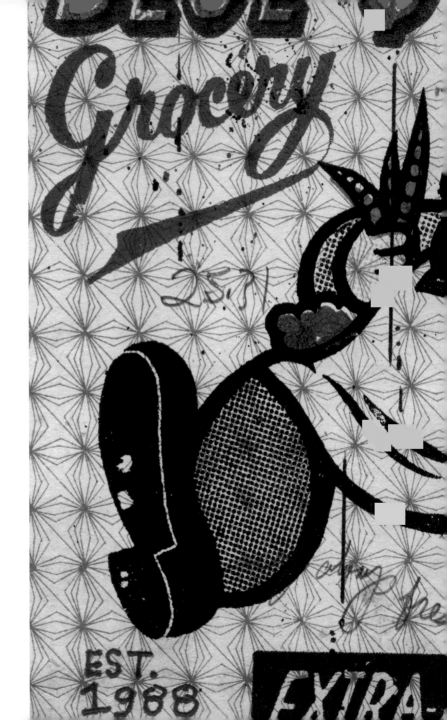

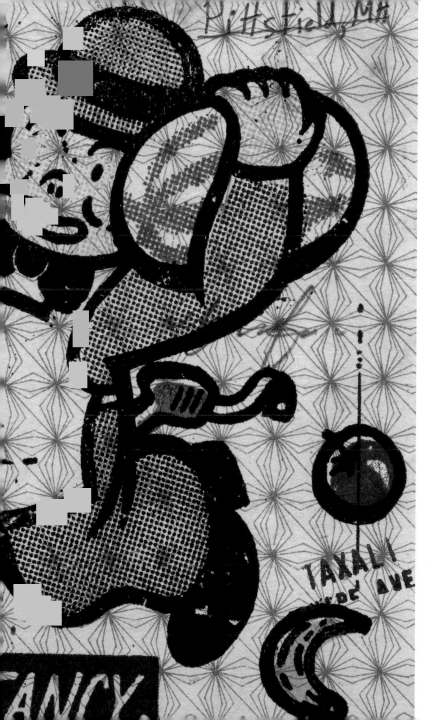

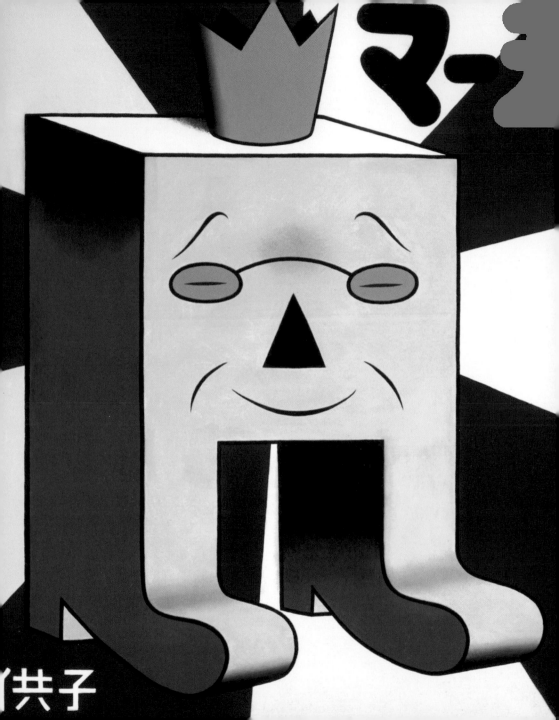

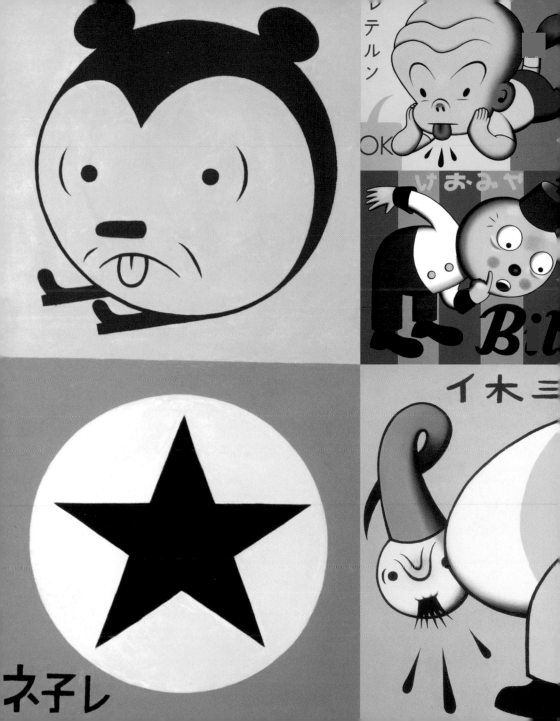

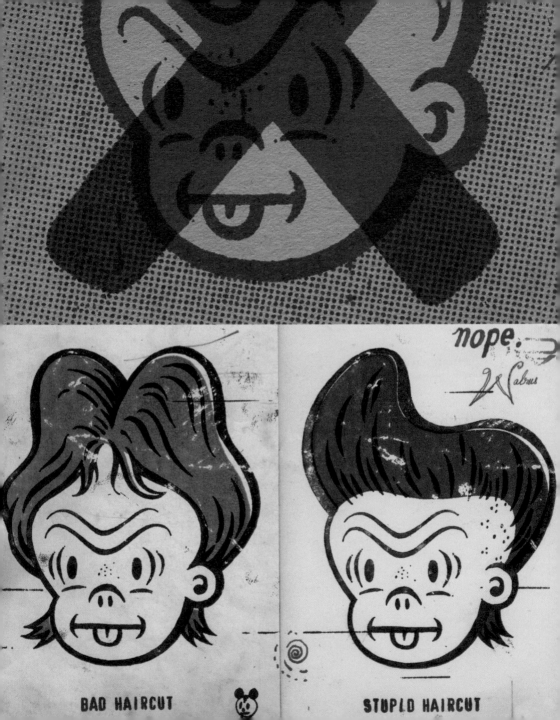

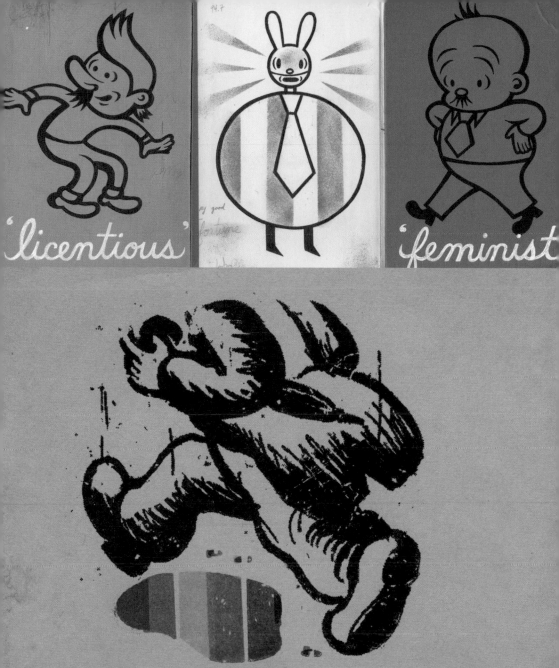

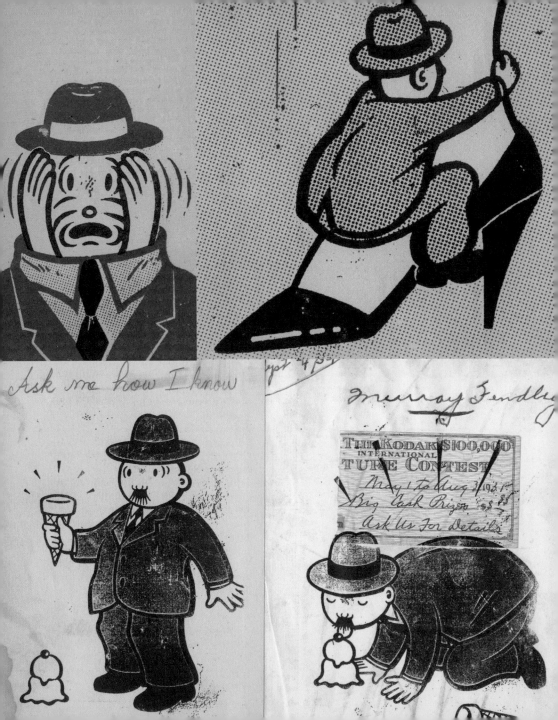

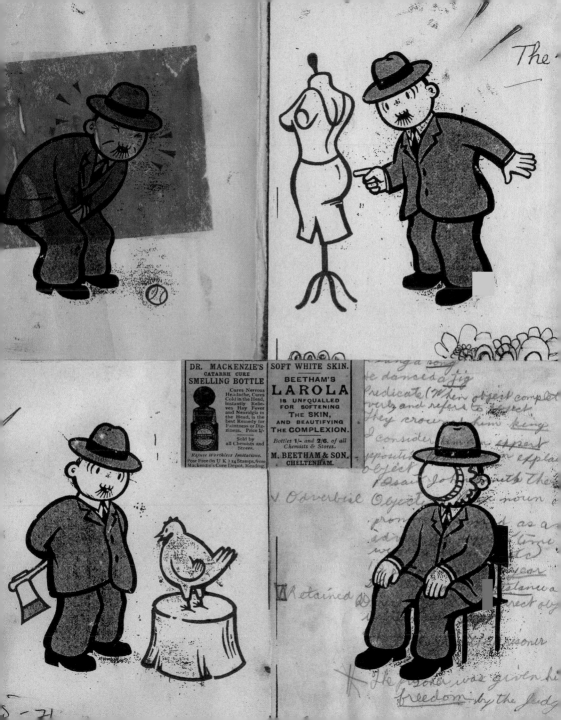

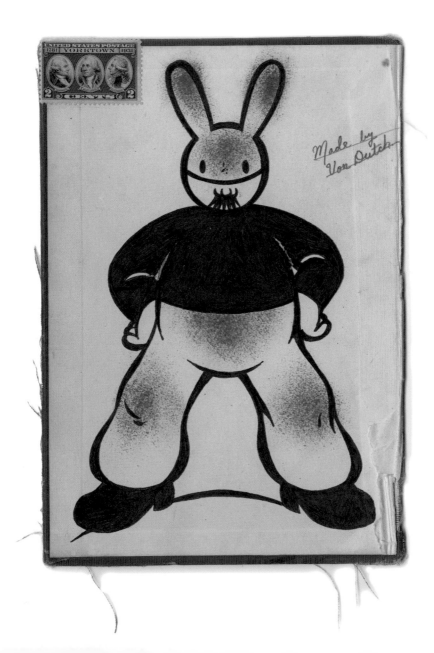

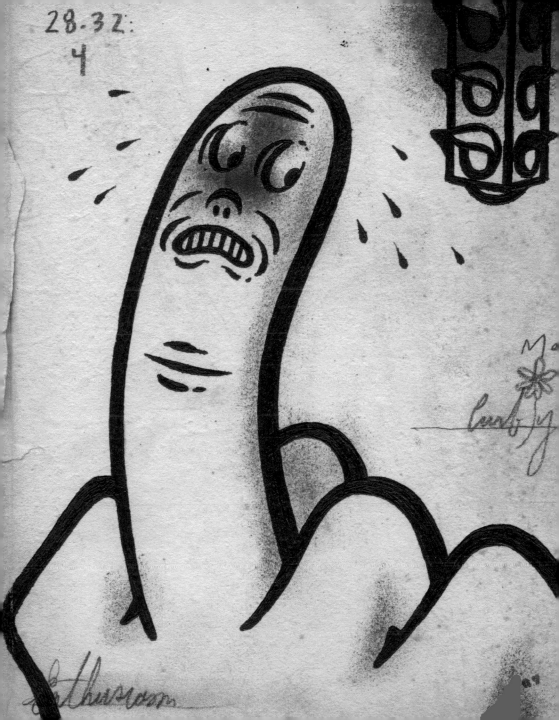

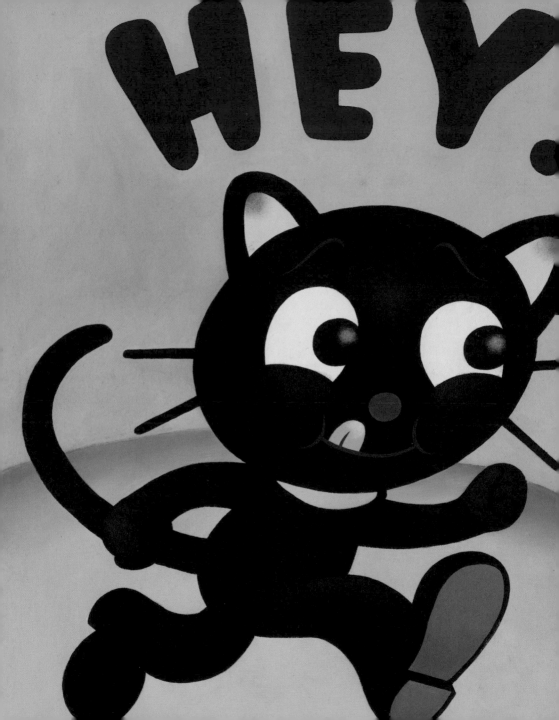

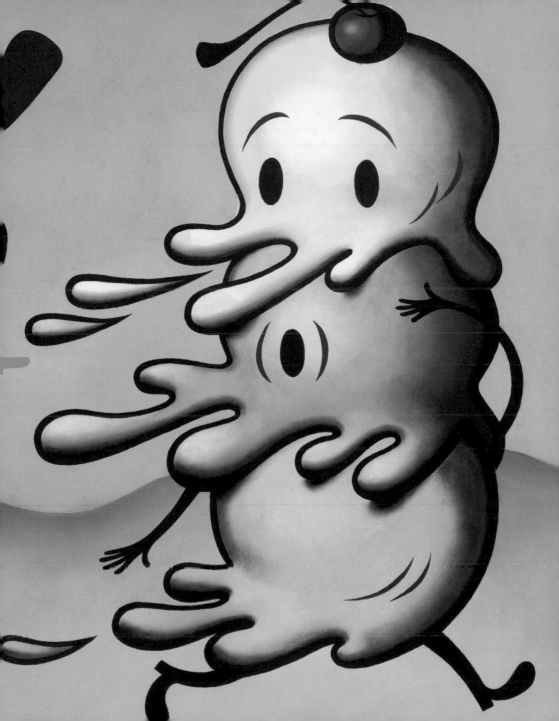

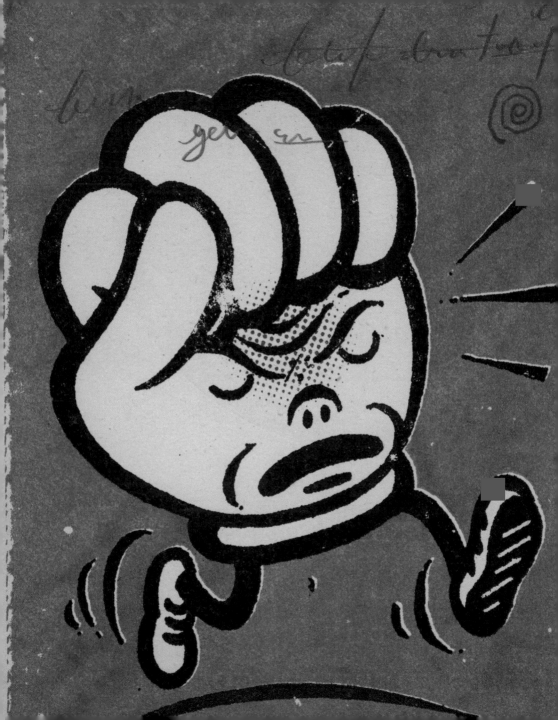

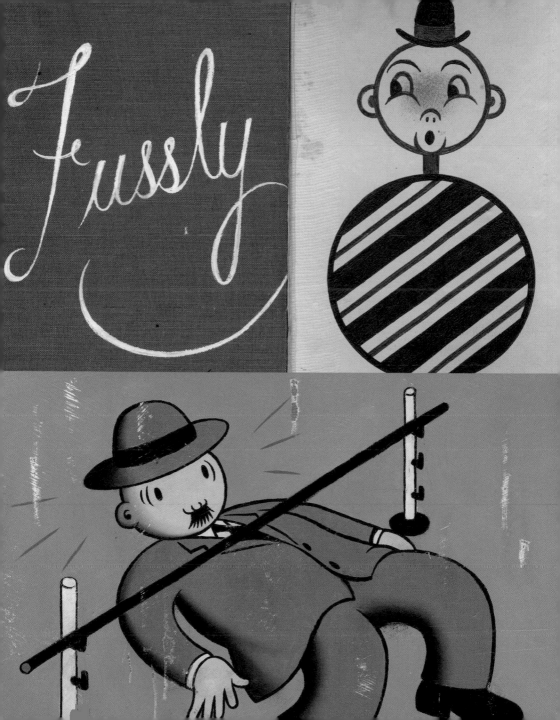

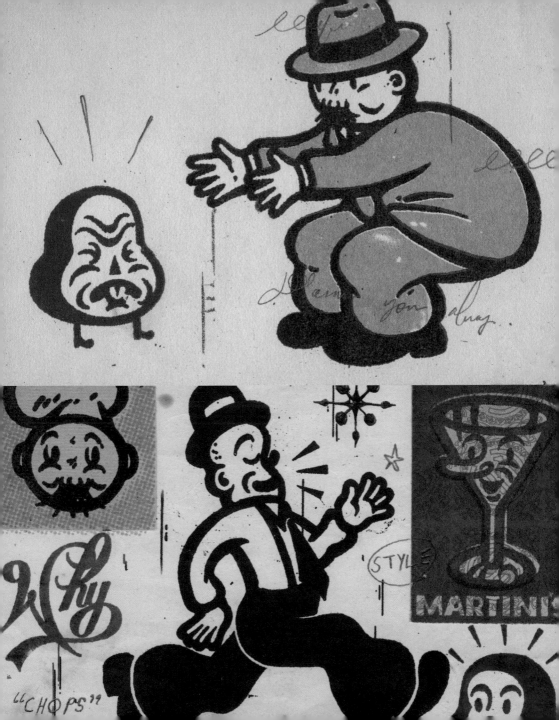

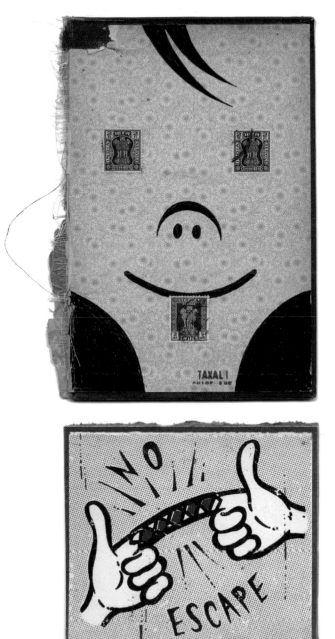

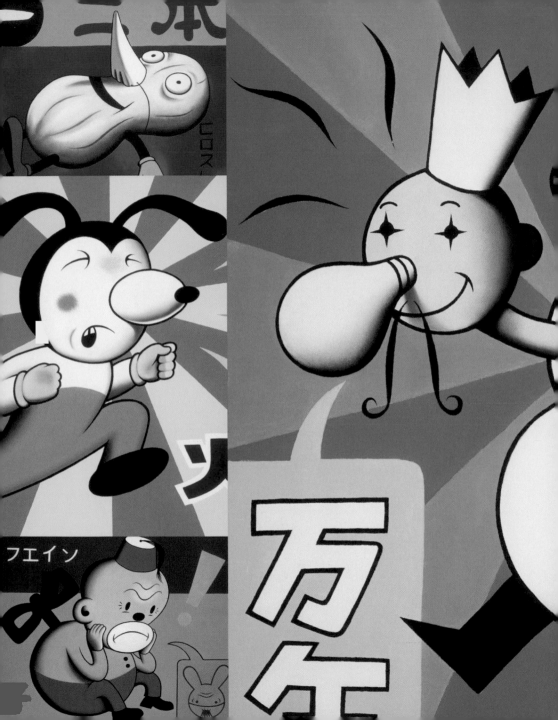

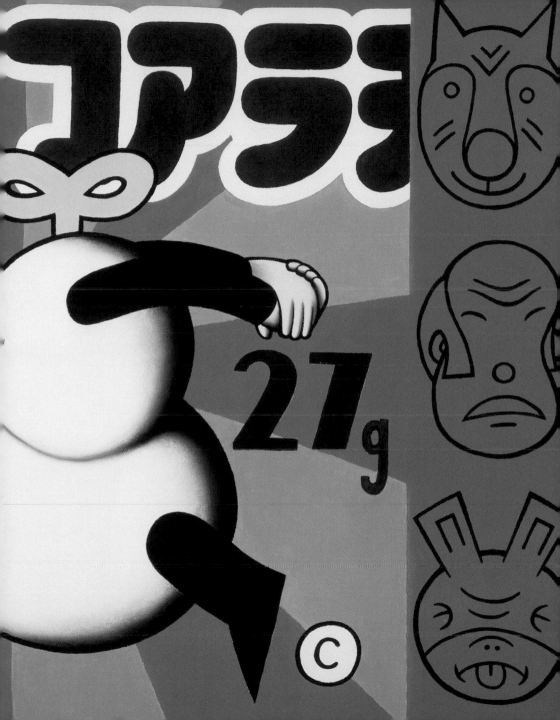

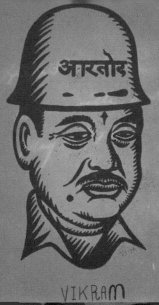

VIKRAM

HOW VIKRAM SEES HIMSELF

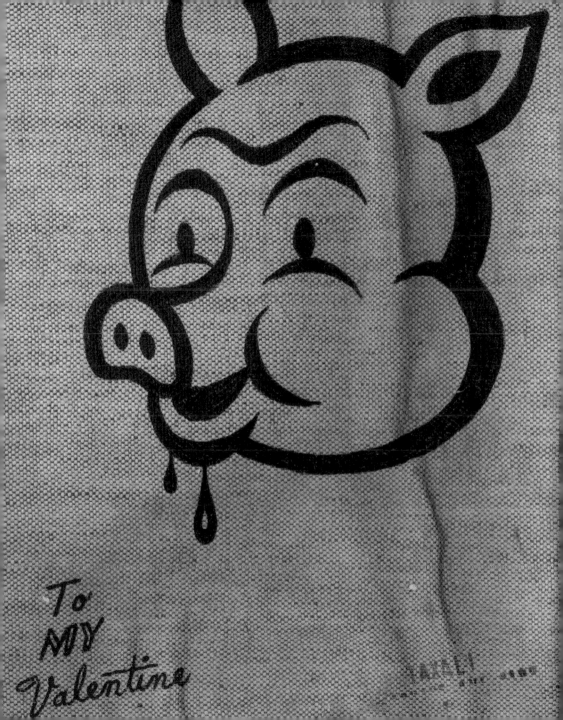

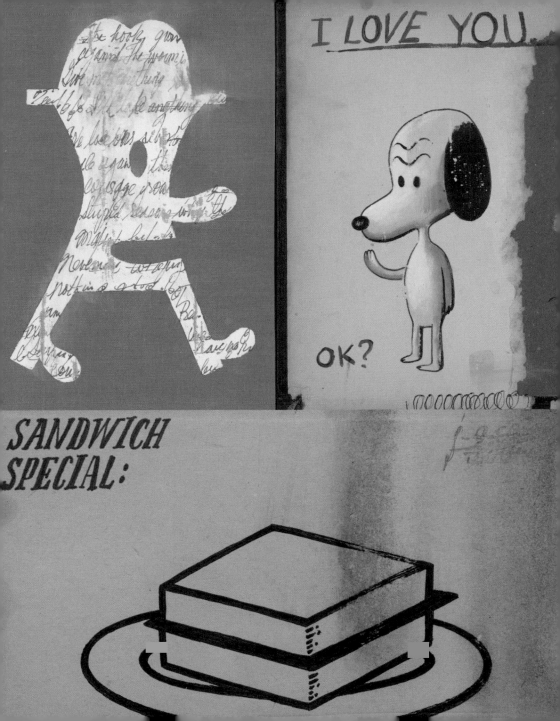

GOOD HUSBAND GOOD LOVER

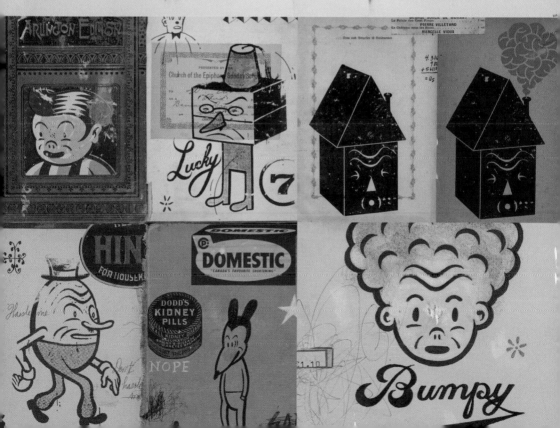

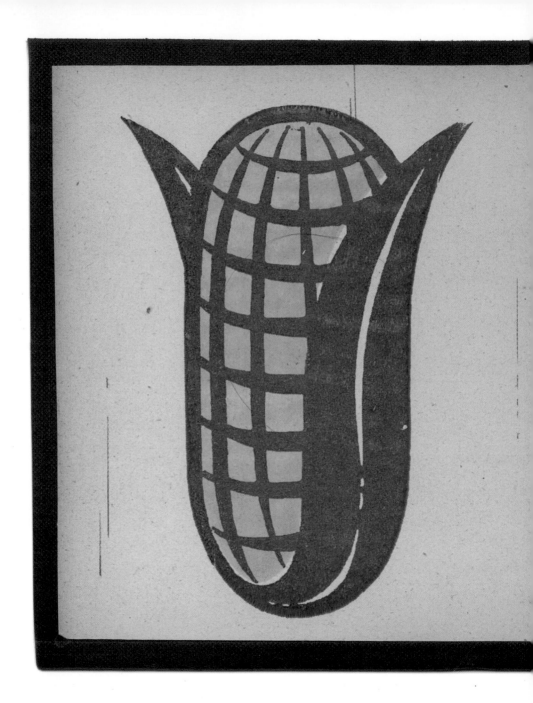

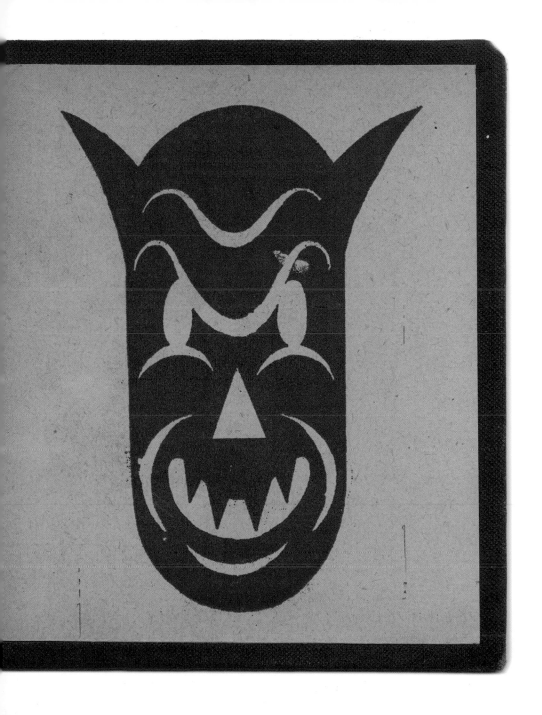

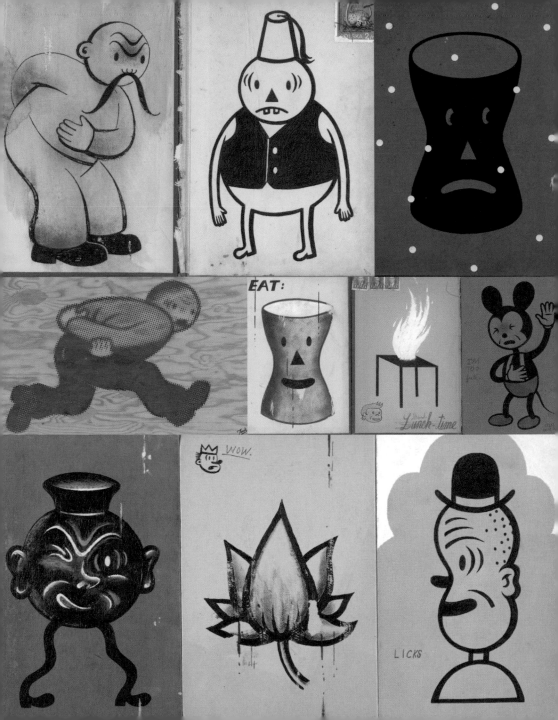

Gary Taxali is an award-winning illustrator, fine artist and toy designer. Gary has worked for clients including *Time, Rolling Stone, Newsweek, GQ,* and *The New York Times.* He has exhibited in many galleries and museums throughout North America and Europe including The Jonathan LeVine Gallery, MondoPOP Gallery, The Antonio Colombo Gallery, The Outsiders (Steve Lazarides' gallery), The Andy Warhol Museum, Museo d'Arte Contemporanea Donna Regina (M.A.D.RE), and The Museum of American Illustration at the Society of Illustrators. In 2005, he launched his first vinyl toy, "The Toy Monkey," which included a special edition along with a silkscreen print commissioned by The Whitney Museum of American Art in New York City. This led Gary to create his own toy company, Chump Toys, which saw the release of his "OH NO" and "OH OH" vinyl figures. Aside from his gallery shows and illustration work, Gary also devotes a portion of his time to teaching and lecturing at various arts organizations and schools such as OCAD University (Toronto, Canada), The Art Directors Club of Houston (Houston, USA), Danmarks Designskole (Copenhagen, Denmark) and Istituto Europeo di Design (Rome, Italy). He is a founding member of IPA (The Illustrators' Partnership of America) and sits on the advisory board of 3×3: *The Magazine of Contemporary Illustration.* Gary has also juried many student and professional competitions including The Society of Illustrators, The National Magazine Awards, The Dallas Society of Visual Communications, and 3×3 *Magazine.* Gary created the cover art and inside illustrations for Aimee Mann's album *@#%&*! Smilers,* which earned a 2009 Grammy Award nomination for Best Art Package. He has also won hundreds of other awards including a gold medal from the Society of Illustrators, a gold medal from the National Magazine Awards Foundation, a Regional and National Gold ADDY®, a shortlist nomination for a Cannes Lion, and numerous awards from American Illustration, Communication Arts Illustration Annual, Print, Society of Publication Designers, The Chicago Creative Club, and The Advertising and Design Club of Canada. In 2010, he released his first children's book entitled *This Is Silly!,* published by Scholastic Press. He lives and works in Toronto, Canada.

This book is dedicated to my loving sister, Vandana Taxali, who is also my agent, lawyer, business partner and above all, my number one fan whose added creativity has increased the scope and realm of possibilities of where I could take my work.

A special thank you to Aimee Mann and Shepard Fairey for not only the wonderful introductions to this book, but for their constant inspiration and support.

Thank you to everyone at teNeues Publishing for the marvelous editing, printing and design of my composition books and this pop art book, especially to Hendrik teNeues, Anshana Arora, Christina Burns, Robb Ogle, Michael Gray and Alwine Krebber.

I would like to also thank my amazing parents, Shashi Taxali and the late Rajinder M. Taxali as well as Elizabeth Abraham, Kathryn Adams, Monika Aichele, Rilla Alexander, Steve Alexander, Gail Anderson, Alexia Angelopoulou, Adrienne Arbour, Kii Arens, Attaboy, Scott Bakal, Sandra Barnes, Ashley Barron, Gary Baseman, Monte Beauchamp, Ximena Becerra, Robert Berger, Bianca Bickmore, Toshi Bindra, Nicholas Blechman, R.O. Blechman, Cathie Bleck, Jay Blumenfeld, Bob Blumer, Linda Book, Adrianne Botrell, Jason Brantly, Shannon Jill Bray, Julia Breckenreid, Lou Brooks, Frederick Burbach, Marc Burckhardt, Chris Buzelli, SooJin Buzelli, John Calabrese, Harry Campbell, Joel Castillo, Franco Cervi, Seymour Chwast, Angela Clayton, Christian Clayton, Frieda Clayton, Rob Clayton, Steve Cober, Tavis Coburn, Fernanda Cohen, Antonio Colombo, Thom Corn, Paul Dallas, Tim Davin, Paul Davis, Trevor Dayton, Julia Deakin, Antonio De Luca, Sara Diamond, Richard Downs, Henrik Drescher, Gérard DuBois, Natasha Eloi, Matt Enger, Leo Espinosa, David Fair, Jad Fair, Phil Falco, Joanna Ferraro, Joseph Daniel Fiedler, Louis Fishauf, Barry Fitzgerald, Tony Fitzpatrick, David Flaherty, Richelle Forsey, Thomas Fuchs, John Gall, My Ganjoo, Reggie Ganjoo, Rishi Ganjoo, Bernadette Gillen, Randall Grahm, Melissa Grant, Mayank Gupta, Kelly Hollyhawk Hartshorne, Tom Hazelmyer, Mark Heflin, Holly Heglin, Steve Heller, Sophie Herken, Thorsten Herken, Hector Herrera, Danielle Hession, Jody Hewgill, Charles Hively, Sam Hiyate, Paul Hodgson, Brad Holland, Phil Holloway, Themis Holloway, Jane Hope, Robert Hunt, Linzie Hunter, Fabio Jacob, James Jean, Margot Jeffery, Long Gone John, Melinda Josie, Terri Cole Juhasz, Victor Juhasz, Nathan Jurevicius, Robin Kachantones, Marc Kauffman, Kory Kennedy, Tony Kerr, Derek Kinsman, Isabel Klett, Jean-Christian Knaff, Jane Ko, Julie Kogler, Joe Kondrat, Laura Konrad, Klim Kozinevich, Stephen Kroninger, Anita Kunz, Emily Lake, Yves Laroche, Paul Lavoie, Steve Lazarides, Lyne Lefebvre, Matthew Lenning, Jonathan LeVine, Lara Licharowicz, John Locke, Tim J. Luddy, Greg Mably, Team Macho, Kathryn Macnaughton, Giorgia Manucci, Henry Mark, Gail Marowitz, Hal Mayforth, Adam McCauley, Aki Darwich-McFadden, Sarah McKinnon, Ian McLaughlin, Kirstin Mearns, Sonny Mehandiratta, Serena Melandri, Aviva Michaelov, Ted Michener, Dean Mitchell, Inigo Martinez Moller, Kenneth Montague, Joe Morse, Ivan Mraz, Martin Mraz, Sarah Munt, Mark Murphy, Steve Mykolyn, Eric Nakamura, Christoph Niemann, Tim O'Brien, Theresa Ortolani, Gary Panter, Fraser Paterson, Michael Penn, Hollie Perez, Louisa St. Pierre, Alain Pilon, Sunil Prakash, Steve Quinlan, Adam Rau, Brian Rea, Reg Rector, Edel Rodriguez, Marc Rosenthal, Helga Rossi, Thilo Rothacker, Graham Roumieu, Balvis Rubess, Joanne Russell, David Saylor, Harry Saylor, Udo Schuster, Scooter, David Scroggy, Vikas Sharma, Yuko Shimizu, Billy Shire, Terry Shoffner, Joanna Sieghart, Karen Simpson, Elwood Smith, Felix Sockwell, Barb Solowan, David Stark, Brian Stauffer, Fred Stonehouse, Katherine Streeter, Amy Szep, Jillian Tamaki, P.J. Tarasuk, Natalie Taylor, Mark Todd, Jason Treat, Anastasia Tzeckas, David Vecchiato, Mike Viglione, Nevin Wadehra, Varun Wadehra, Veerinder Wadehra, Dave Watson, Esther Pearl Watson, Garrick Webster, Kristin Weckworth, Ellen Weinstein, Lawrence Werner, Scott Wetterschneider, Jim White, Corliss Elizabeth Williams, Michael Zaharuk, and Robert Zimmerman.

FRONT COVER "Toy Monkey" (detail), 2000, alkyd oils on masonite, 24"×32", *America Lucky Service* (solo show), La Luz de Jesus Gallery, Los Angeles, USA, Award: *Communication Arts* Illustration Annual 42

BACK COVER "Wallop" (detail), 2008, mixed media on paper, 20"×30", *Flop House Rules* (solo show), Iguapop Gallery, Barcelona, Spain

ENDPAPERS "Monkey Frown", 2008, ink on paper, 4"×8", *@#%♂*! Smilers*, Aimee Mann (album artwork), Award: 2009 Grammy Nomination, Best Art Package

1 "Hi" (detail), 2008, mixed media on paper, 8"×12", *Flop House Rules* (solo show), Iguapop Gallery, Barcelona, Spain, Award: *American Illustration* 28

2 "Lovesick" (icon), 2007, ink on paper, 4"×4", *Men's Health*

3 "Cruisin' USA" (detail), 2002, mixed media, 5"×5.5", Pulse

4 "OK Burger" (detail), 2005, mixed media on paper, 8.9"×13.6", *Chumpy's Specials* (solo show), OX-OP Gallery, Minneapolis, USA

5 "Why Pay More?" (detail), 2007, mixed media on paper, 3"×7", Blue Q

6 "Heart Gift" (icon), 2007

8 "The Damned" (icon), 2007

21 "Sympathy" (icon), 2009

25 "Yo Yo Fun", 2009, mixed media on paper, 13.5"×12.75", *Hindi Love Song* (solo show), Jonathan LeVine Gallery, New York, USA

26 "Right Click My Heart", 2007, mixed media, 6"×9.25", *Last Year's Winner* (solo show), Magic Pony Gallery, Toronto, Canada

27 "UP-man", 2007, mixed media, 5.75"×7.75", *Last Year's Winner* (solo show), Magic Pony Gallery, Toronto, Canada

28 clockwise from left: "Mr. Wobbly", 2006, mixed media on paper, 4"×6", *Men's Health* | "Little Tornado", 2008, ink on paper, 4"×4", *@#%♂*! Smilers*, Aimee Mann (album artwork): Awards: 2009 Grammy Nomination, Best Art Package, *Communication Arts* Illustration Annual 49 | "Grignolino", 2007, ink on paper, 4"×5.2", Bonny Doon Vineyard (wine label) | "Columbus Avenue", 2008, ink on paper, 7.2"×10.3",

@#%♂! Smilers*, Aimee Mann (album artwork), Award: 2009 Grammy Nomination, Best Art Package | "Entertainer of the Year", 2003, alkyd oils on masonite, 12"×9.5", *Entertainment Weekly*

29 "Yo", 2007, mixed media, 5.75"×8", *Last Year's Winner* (solo show), Magic Pony Gallery, Toronto, Canada

30 *"Last Year's Winner"*, 2007, mixed media, 11"×14", *Last Year's Winner* (solo show), Magic Pony Gallery, Toronto, Canada

31 clockwise from left: "Don't Even", 7.5"×13.5", 2009, Mixed Media, 7.5"×9.25", *Hindi Love Song* (solo show), Jonathan LeVine Gallery, New York, USA, | "El Chick Magnet", 2010, mixed media on paper, 7.25"×9.75", *Christmas Group Show*, The Outsiders Gallery (Lazarides), London, UK

32 "I can't quit you" (detail), 2008, mixed media, 8"×11.5", *Flop House Rules* (solo show), Iguapop Gallery, Barcelona, Spain

33 clockwise from left: "Dear You" (detail), 2010, mixed media on paper, 10"×14.5", *Christmas Show* (group show), The Outsiders Gallery (Lazarides), London, UK | "Lust", 2001, mixed media, 7.5"×9", *America Lucky Service* (solo show), La Luz de Jesus Gallery, Los Angeles, USA

34–35 "The Poker Game" (detail), 2006, ink on paper, 20"×20", BLAB! 17, *The Up-N-Down Show* (solo show), La Luz de Jesus Gallery, Los Angeles, USA

36–37 "Whistle Yo Yo" (detail), 2001, alkyd oils on masonite, 24"×32", *America Lucky Service* (solo show), La Luz de Jesus Gallery, Los Angeles, USA

38–39 clockwise from left: "Let's Never Dance" (detail), 8.5"×10.5", *Flop House Rules* (solo show), Iguapop Gallery, Barcelona, Spain | "Jack Boot", 2010, mixed media, 8"×15", *Christmas Group Show*, The Outsiders Gallery (Lazarides), London, UK | "Jail Jeb" (details), 2010, mixed media, *Christmas Group Show*, The Outsiders Gallery (Lazarides), London, UK | "Lukey Pukey" (detail), 4"×6" *Last Year's Winner* (solo show) | "Funnee", 2010, mixed media,

8.5"×11.5", *Christmas Group Show*, The Outsiders Gallery (Lazarides), London, UK | "Prixy" (detail), 2010, mixed media, 15.8"×20.8", 5th Anniversary Group Show, Jonathan LeVine Gallery, New York, USA | "Poon", 2006, 24"×32", *The Up-N-Down Show* (solo show), La Luz de Jesus Gallery, Los Angeles, USA

40 "As Farpas" (detail), 2007, ink on paper, 9.75"×10.25", *Last Year's Winner* (solo show), Magic Pony Gallery, Toronto, Canada

41 "Oh Oh", 2006, alkyd oils on masonite, 24"×32", *The Up-N-Down Show* (solo show), La Luz de Jesus Gallery, Los Angeles, USA

42 "Lovesong Winner", 2009, ink and guache on paper, 8.5"×12", *Hindi Love Song* (solo show) Jonathan LeVine Gallery, New York, USA

43 "Wink", 2006, *The Up-N-Down Show* (solo show), La Luz de Jesus Gallery, Los Angeles, USA

44 clockwise from left: "Love", 2005, mixed media on paper, 7"×9", *Chumpy's Night School* (solo show), La Luz de Jesus Gallery, Los Angeles, USA | "Play" (detail), 2008, mixed media, 8"×10.5", *Flop House Rules* (solo show), Iguapop Gallery, Barcelona, Spain

45 clockwise from left: "Satya", 2010, mixed media, 7"×13", *Christmas Group Show*, The Outsiders Gallery (Lazarides), London, UK | "Hell", 2009, mixed media on paper, 8"×10.75", *Hindi Love Song* (solo show) Jonathan LeVine Gallery, New York, USA, Award: *American Illustration* 29 | "Let it Ride", 2008, mixed media, 7"×9.5", *Flop House Rules* (solo show), Iguapop Gallery, Barcelona, Spain | "Puffle", 2001, 4.5"×7.5", *America Lucky Service* (solo show), La Luz de Jesus Gallery, Los Angeles, USA

46 clockwise from left: "Well Thought Out Plan", alkyd oil on masonite, 48"×64", *Hindi Love Song*: Jonathan Levine Gallery, New York, USA | "Free" (detail), 2002, mixed media, 12.5"×6.25", personal work

47 "Binco Rabbit" (detail), 2001, mixed media, 4.5"×7" *America Lucky Service* (solo show), La Luz de Jesus Gallery, Los Angeles, USA, Award: *American Illustration* 20

48–49 clockwise from left: "Ruddy Deal" (detail), 2010, mixed media on paper, 6.75"×18", *Christmas Group Show*, The Outsiders Gallery (Lazarides), London, UK | "Special Effects", 2004, ink on paper, 6"×8.8", *Fast Company* | "Puke Kid", 2006, mixed media, Ad for Anti Stock Campaign, The Illustration Growers of America, Awards: Society of Illustrators 50 (Gold Medal), *American Illustration* 24, *Communication Arts* Illustration Annual 47, Cannes Lion Shortlist, National Addy, Regional Addy, Chicago Art Directors Club, *Applied Arts* Magazine | "Risk Management" (detail), 2005, ink on paper, 4"×5.5", *Fortune* Magazine | "Disinclination" (2 details), 2009, ink on paper, 8"×12.3", *The Atlantic Monthly, The Taxali 300* (solo show), Narwhal Art Projects, Toronto, Award: *American Illustration* 29
50–51 "Tripping Over Fees" (detail), 2006, mixed media on paper, 5"×8.65", Plansponsor
52 "Chi-town", 2007, limited edition silkscreen print, 22"×27.5"
53 "Hindi Nicknames", 2009, mixed media, 21.25"×27", *Hindi Love Song* (solo show), Jonathan LeVine Gallery, New York, USA
54–55 clockwise from left: "Sometimes is Never Enough", 2005, ink on paper, 16"×16", *BLAB!* 16 | "Totally Repugnant/ Immensely Appetizing", 2004, mixed media on paper, 8.65"×11.63", Bonny Doon Vineyard (Wine Label), Awards: *American Illustration* 22, *Applied Arts* Best of Show | "Eyes Popping", 2005, ink on paper, 3.5"×3", *Nickelodeon Magazine* | "Stuff", 2008, alkyd oil on masonite, 18"×18", *BLAB!* 19 | "Fun", 2008, alkyd oil on masonite, 18"×18", *BLAB!* 19
56–57 clockwise from left: "Cabernet Sauvignon", 2004, mixed media, 6"×7", Bonny Doon Vineyard (Wine Label) | "Stranger to Starman", 2008, ink on paper, 3.5"×3.5", *@#%&*! Smilers,* Aimee Mann (album artwork), Award: 2009 Grammy Nomination, Best Art Package | "Always the Same" (detail), 2005, mixed media, 8"×8.5" *Chumpy's Night School*, La Luz de Jesus Gallery, California

| "Cigare C", 2005, mixed media on paper, 7.3"×9", Bonny Doon Vineyard (Wine Label) | "Artist of the Year", 2007, mixed media on paper, 4"×6", *Last Year's Winner* (solo show), Magic Pony Gallery, Toronto, Canada | "Ghum-Drop" (detail), 2007, mixed media, 7.75"×10.25", *Last Year's Winner* (solo show), Magic Pony Gallery, Toronto, Canada
58 "5 Rupee" (detail), 2002, mixed media, 9.5"×12.5", *Cubed* (group show), Tin Man Alley, Philadelphia, PA | "Bright Side", 2009, ink on paper, 4"×6", *The New York Times Book Review*
59 "It's Over", 2008, mixed media, 7"×9.8", *@#%&*! Smilers,* Aimee Mann (album artwork), Awards: 2009 Grammy Nomination, Best Art Package, *Communication Arts* Illustration Annual 49 | "Dimple-Tinku", 2007, enamel oils on aluminum, 19"×24", *Last Year's Winner* (solo show), Magic Pony Gallery, Toronto, Canada
60–61 "Heed" (detail), 2007, enamel oils on aluminum, 20"×20", *BLAB!* 18, *Last Year's Winner* (solo show), Magic Pony Gallery, Toronto, Canada
62 "Faker", 2009, mixed media, 9"×11.5", *Hindi Love Song* (solo show), Jonathan LeVine Gallery, New York, USA, Award: *American Illustration* 29
63 "Dil Ki Rath", 2009, mixed media, 7.25"×9.5", *Hindi Love Song* (solo show), Jonathan LeVine Gallery, New York, USA
64 "Chump 3D" (detail), 2009, ink on plywood, 20"×32", *Hindi Love Song* (solo show), Jonathan LeVine Gallery, New York, USA
65 "Red/Black Trailer", 2008, oil on plywood, 11"×17", *Flop House Rules* (solo show), Iguapop Gallery, Barcelona, Spain- "Spycars", 2008, oil on plywood, 11"×17", *Flop House Rules* (solo show), Iguapop Gallery, Barcelona, Spain
66–67 "Fried 24 Hours", 2007, oil on plywood, 11"×17", *Last Year's Winner* (solo show), Magic Pony Gallery, Toronto, Canada
68 "Devil Tongue", 2008, alkyd oil and collage on plywood, 11"×17", Copro Gallery, Santa Monica, CA
69 "Borrowing Time" (detail), 2008, mixed media on paper, 5"×5.3", *@#%&*! Smilers,*

Aimee Mann (album artwork), Awards: 2009 Grammy Nomination, Best Art Package, *Communication Arts* Illustration Annual 49, *American Illustration* 27 | "Phoenix" (detail), 8"×7.5", *@#%&*! Smilers,* Aimee Mann (album artwork), Awards: 2009 Grammy Nomination, Best Art Package, *American Illustration* 27 | "Medicine Wheel", 2008, mixed media, 7.8"×7.9", *@#%&*! Smilers,* Aimee Mann (album artwork), Award: 2009 Grammy Nomination, Best Art Package | "Salvation" (detail), 2008, mixed media, 7"×7", *@#%&*! Smilers,* Aimee Mann (album artwork), Award: 2009 Grammy Nomination, Best Art Package | "Great Beyond", 2008, mixed media, 6"×9", *@#%&*! Smilers,* Aimee Mann (album artwork), Award: 2009 Grammy Nomination, Best Art Package | "Ballantine's", 2008, mixed media, 4"×4", *@#%&*! Smilers,* Aimee Mann (album artwork), Award: 2009 Grammy Nomination, Best Art Package
70–71 "Wednesday Thursday", 2009, mixed media on paper, 7.75"×8.5", *Hindi Love Song* (solo show), Jonathan LeVine Gallery, New York, USA
72 "Good/Bad Daisy", 2003, alkyd oils on masonite, 9"×11", *Entertainment Weekly*
73 "She Loves Me", 2003, alkyd oils on masonite, 9"×11", *Entertainment Weekly*
74–75 "In Like", 2010, mixed media, 8"×10.5", *Blow Up* (group show), G. Gibson Gallery, Seattle, WA
76 "Chumo" (detail), 2009, enamel oils on aluminum, 23.75"×23.75", *Hindi Love Song* (solo show), Jonathan LeVine Gallery, New York, USA
77 "Dillu" (detail), 2007, enamel oils on aluminum, 20"×20", BLAB! 18, *Last Year's Winner* (solo show), Magic Pony Gallery, Toronto, Canada
78–79 "Lunchbox" (detail), 2005, mixed media, 10"×10", *Chumpy's Night School* (solo show), La Luz de Jesus Gallery, Los Angeles, USA | "Row Box" (detail), 2010, alkyd oils on wood panel, 10"×14", *Christmas Group Show*, The Outsiders Gallery (Lazarides), London, UK, Award:

Society of Illustrators 53
80 "Woo", 2006, alkyd oil on masonite, 32"×34.5", *The Up-N-Down Show* (solo show), La Luz de Jesus Gallery, Los Angeles, USA | "Mourvedre" (detail), 2004, mixed media on paper, 8.8"×10.3", Bonny Doon Vineyard (Wine Label) Award: *Communication Arts* Illustration Annual 43
81 "Make No your Bitch" (detail), 2007, ink on paper, 5"×6.5", Paul Lavoie, TAXI Advertising | "Real" (detail), 2008, ink on plywood, 11"×17", *Flop House Rules* (solo show), Iguapop Gallery, Barcelona, Spain | "Grenache Sinsault UFO" (detail), 2003, Alkyd oils on masonite, 9"×12", Bonny Doon Vineyard (Wine Label) | "Freeway", 2008, mixed media, 5.8"×6.2", @#%&*! *Smilers,* Aimee Mann (album artwork), Award: 2009 Grammy Nomination, Best Art Package | "Black Eye", 2004, mixed media, 6"×8.5", *Men's Fitness,* Award: *American Illustration* 23
82 "The Day the Coffee Died", 2010, mixed media on paper, 4"×6", National Novel Writing Month (book jacket cover unpublished)
83 "Forget It", 2005, mixed media, 19"×22.5", *Chumpy's Night School* (solo show), La Luz de Jesus Gallery, Los Angeles, USA
84 "Circumcision", 2010, ink on paper, 4"×4", *Mother Jones,* Awards: *Communication Arts* Illustration Annual 51, *3×3* Illustration Annual Number 7
85 "OH NO Bronze", 2007, bronze sculpture, 3.5"×6.5", *Last Year's Winner* (solo show), Magic Pony Gallery, Toronto, Canada
86–87 "Funly" (detail), 2007, enamel oils on aluminum, 13"×24", *BLAB!* 18, *Last Year's Winner* (solo show), Magic Pony Gallery, Toronto, Canada
88 "Installation of Various Mini Serigraphs", 2008, mixed media on paper, *OH NO & OH OH Vinyl Figure Launch Party and Signing,* Magic Pony, Toronto
89 "OH NO", 2005, mixed media on handmade Gampi paper, 29"×22", *Chumpy's Night School* (solo show), La Luz de Jesus Gallery, Los Angeles, USA, Award: *American Illustration* 24
90–91 "Installation of Various Mini Serigraphs & OH NO

Sculpture", 2008, mixed media on paper: Styrofoam, plaster, acrylic resin, 48"×32", *OH NO & OH OH Vinyl Figure Launch Party and Signing,* Magic Pony, Toronto
92–93 "Installation of Various Mini Serigraphs", 2008, mixed media on paper, *OH NO & OH OH Vinyl Figure Launch Party and Signing,* Magic Pony, Toronto
94–95 "*Last Year's Winner* Sculpture" 2007, Styrofoam, plaster, acrylic resin, wood, 70"×35", *Last Year's Winner* (solo show), Magic Pony Gallery, Toronto, Canada
96 "*Last Year's Winner* Sculpture", Installation, 2007, Styrofoam, plaster, acrylic resin, wood, 70"×35", *Last Year's Winner* (solo show), Magic Pony Gallery, Toronto, Canada
97 "My Feelings #2", 2009, ink on plywood, 20"×32", *Hindi Love Song* (solo show), Jonathan LeVine Gallery, New York, USA
98 "Fun" (detail), 2009, mixed media, 9"×12.25", *Hindi Love Song* (solo show), Jonathan LeVine Gallery, New York, USA, Award: *American Illustration* 29
99 "Installation of Various Mini Serigraphs", 2008, mixed media on paper, *OH NO & OH OH Vinyl Figure Launch Party and Signing,* Magic Pony, Toronto
100–101 "Straight Up", 2009, mixed media,10.75"×17.5", *Hindi Love Song* (solo show), Jonathan LeVine Gallery, New York, USA
102 "Go Lucky", 2009, alkyd oils on wood, 34"×50", *Hindi Love Song* (solo show), Jonathan LeVine Gallery, New York, USA
103 "Un-Dork" (detail), 2008, mixed media on paper, 8.5"×10.5", *Flop House Rules* (solo show), Iguapop Gallery, Barcelona, Spain
104–105 "Un-Sad", 2005, mixed media, 7.7"×10.3", *Chumpy's Specials* (solo show), OX-OP Gallery, Minneapolis, USA
106–107 "Grocer Man" (detail), 2007, ink on paper, 4.5"×4,5", Blue Q
108–109 Clockwise from left: "ChooChoo Restaurant", 2001, alkyd oils on masonite, 24"×32", *America Lucky Service* (solo show), La Luz de Jesus Gallery, Los Angeles, USA | "Ok", 2001, alkyd oils on masonite, 24:×32", *America Lucky Service* (solo show), La Luz de Jesus Gallery, Los

Angeles, USA | "Bilu", 2001, alkyd oils on masonite, 24:×32", *America Lucky Service* (solo show), La Luz de Jesus Gallery, Los Angeles, USA | "America Lucky Service" (detail), 2001, alkyd oils on masonite, 24"×32", *America Lucky Service* (solo show), La Luz de Jesus Gallery, Los Angeles, USA, Award: Society of Illustration 43 Silver Medal
110 "No Kids", 2005, ink on paper, 4"×4.6", *Minnesota Monthly* | "Bad Haircut/Stupid Haircut", 2004, mixed media, 5.63"×7.7", *Men's Fitness*
111 top to bottom: "Licentious Feminist", 2004, mixed media, 8.3"×16.83", Murphy Design, *Heaven and Hell* book | "Puddle", 2009, ink on paper, The Walrus, Award: *American Illustration* 28
112 Clockwise from left: "Financial Risks" (detail), 2009, ink on paper, 4"×5.6", *The New York Times Magazine,* Award: *American Illustration* 28 | "Women" (one from the series: 4 Vices of Men) 2008, ink on paper, 4"×4.25", Hobbs & Kent (cuff links) | "Monday Tuesday" (detail), 2002, mixed media, 8.5"×11.8", personal work
113 "What It Feels Like", 2004, mixed media on paper, 10"×12", *Esquire,* Award: *American Illustration* 23
114 "Made By", 2008, mixed media, 5.6"×8.3", Murphy Design, *Von Dutch Tribute Book*
115 "Flipping the Bird", 2007, mixed media on paper, 4.9"×6.9", *Men's Health*
116–117 "Hey", 2010, alkyd oils on wood panel, 30"×40", Sanrio 50th Anniversary Group Show, JapanLA, Los Angeles, CA
118 "Fist", 2008, ink on paper, 5"×6.7", *Runner's World*
119 Top to bottom: "Fussly" (detail), 2009, mixed media, 7.5"×10.25", *Hindi Love Song* (solo show), Jonathan LeVine Gallery, New York, USA | "Limbo", 2003, alkyd oil on masonite, 11"×17", *Bloomberg Magazine*
120 Top to bottom: "Embrace Your Fears", 2010, mixed media on paper, 4"×6", *CIO* Magazine | "Eddie Martinis", 2009, mixed media, 4"×6", Eddie Martini's Steak House, Award: Society of Illustrators 51
121 Top to bottom: "Cowlick",

2007, mixed media, 5"×7.75", *Last Year's Winner* (solo show), Magic Pony Gallery, Toronto, Canada | "Finger Trap" (detail), 2007, ink on paper, 4.2"×4.6", Practical Joke Kit
122–123 Clockwise from left: "Toy Peanut" (detail), 2001, alkyd oil on masonite, 34"×28", *America Lucky Service* (solo show), La Luz de Jesus Gallery, Los Angeles, USA | "Truly Delicious Taste" (detail), 2001, alkyd oil on masonite, 36"×28", *America Lucky Service* (solo show), La Luz de Jesus Gallery, Los Angeles, USA |
"Toy Monkey", 2001, alkyd oil on masonite, 34"×28", *America Lucky Service* (solo show), La Luz de Jesus Gallery, Los Angeles, USA, Award: *Communication Arts Illustration Annual 42* | "Speed" (detail), 2001, alkyd oil on masonite, 36"×28", *America Lucky Service* (solo show), La Luz de Jesus Gallery, Los Angeles, USA
124–125 Clockwise from left: "Vikram", 2002, mixed media on paper, 6.7"×8.6", personal work, Award: *American Illustration 21* | "Wishing" (detail), 2001, mixed media, 14.5"×17.5", *America Lucky Service* (solo show), La Luz de Jesus Gallery, Los Angeles, USA, Award: *American Illustration 20* | "To My Valentine", 2008, mixed media, 5"×7.5", *Flop House Rules* (solo show), Iguapop Gallery, Barcelona, Spain | "Crap" (detail), 2001, ink on plywood, 11"×17", *America Lucky Service* (solo show), La Luz de Jesus Gallery, Los Angeles, USA
126 "I Love You OK", 2005, mixed media, 8"×11", *Chumpy's Night School* (solo show), La Luz de Jesus Gallery, Los Angeles, USA | "Sandwich Special" (detail), 2008, mixed media, 4.5"×7.5", *Flop House Rules* (solo show), Iguapop Gallery, Barcelona, Spain
127 Clockwise from left: "Good Husband, Good Lover" (detail), 2005, mixed media on handmade gampi paper, 29"×43", *Chumpy's Night School* (solo show), La Luz de Jesus Gallery, Los Angeles, USA, Award: *American Illustration 24* | "Grey Smoke", 2008, mixed media on paper, 7.5"×10", *Flop House Rules* (solo show), Iguapop Gallery, Barcelona, Spain

| "Bumpy" (detail), 2003, mixed media, 5.5"×5.5", Murphy Design, Utopia book, *Chumpy's Night School* (solo show), La Luz de Jesus Gallery, Los Angeles, USA | "Unfamous" (detail), 2005, mixed media, 14.5"×9.25", *Chumpy's Night School* (solo show), La Luz de Jesus Gallery, Los Angeles, USA
128–129 "Evil Corn", 2009, ink on paper, 4.75"×7.75", *Mother Jones*
130–131 Clockwise from left: "Pow-Pow" (detail), 2008, mixed media, 7.5"×10", mixed media, *Flop House Rules* (solo show), Iguapop Gallery, Barcelona, Spain | "MM" (detail), 2002, mixed media, 5"×8.2",1000 Journals, Award: *American Illustration 21* | "1000" (detail), 2002, mixed media, 5"×8.2", 1000 Journals, Award: *American Illustration 21* | "Any Thing Festive Goes" (detail), 2010, mixed media, 5"×13.9" Aubin & Wills, Awards: Society of Illustrators 53 | "Sangiovese" (detail), 2002, ink on paper, 7"×9.6", Bonny Doon Vineyard (wine label)
132 Clockwise from left: "Howdy, Friend", 2005, mixed media, *Chumpy's Specials* (solo show), OX-OP Gallery, Minneapolis, USA | "Golden Garden", 2007, mixed media, 7.75"×10.75", *Last Year's Winner* (solo show) Magic Pony Gallery, Toronto, Canada | "Eat", 2005, mixed media, 7.3"×15", *Chumpy's Specials* (solo show), OX-OP Gallery, Minneapolis, USA | "Licks", 2005, mixed media, 8"×16.5", *Chumpy's Night School* (solo show), La Luz de Jesus Gallery, Los Angeles, USA | "Whoop #2" (detail), 2009, ink on plywood, 20"×32", *Hindi Love Song* (solo show) Jonathan LeVine Gallery, New York, USA
133 "Ghee", 2006, alkyd oils on masonite, 24"×32", *The Up-N-Down Show* (solo show), La Luz de Jesus Gallery, Los Angeles, USA
134–135 "Spirit Club Dance", 2005, mixed media, 8"×10.5", *Chumpy's Night School* (solo show), La Luz de Jesus Gallery, Los Angeles, USA | "Puffles" (detail), 1999, mixed media on paper, 9.6"×11.2", personal piece
142 "Heart Gift" (icon), 2007
143 "End World" (icon), 2009, BLABWORLD #1, *Artpocalypse*

144 "Farewell Party", 2010, mixed media on paper, 5"×8.5", *Christmas Group Show*, The Outsiders Gallery (Lazarides), London, UK

© 2011 teNeues Verlag GmbH + Co. KG, Kempen
Artwork © 2011 Gary Taxali. All rights reserved.
www.garytaxali.com
www.taxali.com
www.taxalionline.com/blog

Foreword by Shepard Fairey and Aimee Mann
Translations by:
Carmen Berelson (German)
Helena Solodky-Wang (French)
Beatriz Paganini Álvarez (Spanish)
Michela Martini (Italian)
Editorial Coordination by Anshana Arora
Design by Robb Ogle
Production by Nele Jansen, Dieter Haberzettl
Color Separation by Medien Team-Vreden, Germany

Photography Credits:
Richelle Forsey: pages 85, 88, 90–91, 92–93, 94–95, 96, 99
Theresa Ortolani: page 108
Lawrence Werner: page 146

FSC
www.fsc.org
MIX
Paper from
responsible sources
FSC® C023419

Published by teNeues Publishing Group
teNeues Verlag GmbH + Co. KG
Am Selder 37, 47906 Kempen, Germany
Phone: +49-(0)2152-916-0
Fax: +49-(0)2152-916-111
e-mail: books@teneues.de

Press department: Andrea Rehn
Phone: +49-(0)2152-916-202
e-mail: arehn@teneues.de

teNeues Digital Media GmbH
Kohlfurter Straße 41–43, 10999 Berlin, Germany
Phone: +49-(0)30-7007765-0

teNeues Publishing Company
7 West 18th Street, New York, NY 10011, USA
Phone: +1-212-627-9090
Fax: +1-212-627-9511

teNeues Publishing UK Ltd.
21 Marlowe Court, Lymer Avenue, London SE19 1LP, UK
Phone: +44-(0)20-8670-7522
Fax: +44-(0)20-8670-7523

teNeues France S.A.R.L.
39, rue des Billets, 18250 Henrichemont, France
Phone: +33-(0)2-4826-9348
Fax: +33-(0)1-7072-3482

www.teneues.com

ISBN 978-3-8327-9511-5
Library of Congress Control Number: 2011927187
Printed in Italy

teNeues Publishing Group
Kempen
Berlin
Cologne
Düsseldorf
Hamburg
London
Munich
New York
Paris

teNeues

Bibliographic information published by the Deutsche Nationalbibliothek.
The Deutsche Nationalbibliothek lists this publication in the Deutsche Nationalbibliografie; detailed bibliographic data are available in the Internet at http://dnb.d-nb.de.